[*introduction*]

.stry

.tainment, Leisure, Retai

mation, Financial, Publi

ology, New Media

advertising

direct marketing

print
- corporate communications
- marketing collateral

entertainment marketing
(domestic & international)

new media
online marketing
web site development
multimedia development

home
about fb
featured work
clients & services
client access
careers
contact

XPLANE home visual thinking contact us portfolio of work our people

In my consulting and teaching, I meet a lot of creative people who have one thing in common: they love what they do, but they don't love promoting what they do. They wish the work would fall from the sky.

Of course, it doesn't. Getting the work you want requires active and consistent self-promotion. That's why, in this book, I have tried to weave some basic, tried-and-true marketing concepts in and around the more practical ideas for using these newfangled electronic tools. Because no matter how intense the dot-com hype, the Internet is no marketing panacea. A lot of what happens out there in cyberspace may be a mystery, but it's not magic.

You must spread the word. *You* must speak up if you want to be heard; your work will not speak for itself. *You* must listen and respond to your prospects. *You* must offer something of substance and of value. *You* must participate.

So get ready to add a very powerful medium to your message, because if you make a commitment to promoting yourself and your services, both online and offline, your business will grow.

"I have sent out mailers. I have a Web page. When am I going to start getting the jobs?"

Anonymous message posted on "Art Talk," the discussion forum at the portfolio site Theispot-Showcase (www.theispot-showcase.com)

"Thanks to new media, it's now possible for designers, photographers and illustrators to show off their work in more intriguing and more immediate ways than in the acetate sleeves of the standard black leather portfolio case. These new media provide a more engaging way to tell others about yourself, your company and your creative potential."

Jack Davis and Susan Merritt, *The Web Design Wow! Book*

*section.***one**

web site as a

web site as a marketing tool

marketing tool

chapt

chapter 1

esign services in the fo
ts that require a mix of

Graphic Desi

We create any and all
of its identity: print
information; publications f
newspapers; the form and l
environmental graphics.

Archi

The struc
spaces f
and buildin
exhibitions
Recent Wor

creating an effective web site

A Web site can be one of the most rewarding marketing tools you will ever use, because it can help you expand your business in ways never before possible. It shows that you're up-to-date, gives you instant credibility and expands your market globally and exponentially. But most important of all, the World Wide Web makes possible access anytime to examples of your work. Your prospects can get information when they need it without having to wait for you to send it, making it supremely simple for anyone to check you out and satisfying the desire for instant gratification that is pervasive in our digital economy.

In this and the next two chapters we'll examine the Web sites of several creative firms who present themselves successfully—from a marketing point of view—on the Web. Whether your Web site is up and running or you're still in the preparation stages, this section will help you make your site one that will achieve your marketing goals.

"I am certain that soon the Web will be the primary medium for advertising in our business. It will be immediate, it will be up-to-date and it will provide a medium in which artists can show their work in the best possible light."

Bud Peen, illustrator (www.budpeen.com)

Promoting with the Web

 Registering Your Domain

To quickly register your domain name, try either of these two sites:

www.register.com

www.networksolutions.com

If you're like most creative types, marketing is not your favorite thing to do. You'd rather be doing your work; that's why you chose it. But deep down you know you have to promote your talents and services, otherwise no one will be able to find you and offer you the work you want. So you probably have at least one self-promotion project that just never got finished, be it a brochure to demonstrate your print talents or an impressive 3-D piece to show off your package design skills. The reason these projects don't get off the back burner is because you want your own marketing materials to be perfect—and your standards are very high.

A Web site is one marketing tool, however, that doesn't seem to live on the back burner. In fact, the opposite is true. Many designers and other creative professionals have slapped their sites up without much planning, perhaps in preparation for an event or because a client says, "Give me your Web address," or maybe just because everyone else is doing it.

[*definition*]

What is a URL?
URL is the abbreviation for Uniform Resource Locator, which is the Web address or Internet address of a Web site or page.

Jeff Fisher, of Jeff Fisher LogoMotives in Portland, Oregon, created his site in three days. "My Web site went up out of an immediate need. The largest newspaper in the state was doing a major feature story on my business. I'd been talking about a Web site for almost a year. Suddenly I had to quit talking about it and do something."

Some designers put a site up quickly and then revamp it. In fact, most of the creative professionals featured in this book are on the second or third iteration of their Web site, as they've learned from the comments of visitors and from their Web reports what works and what doesn't. Others work on their site for a long time—getting it ready, making it perfect—while the domain remains "under construction" or a temporary page holds its place—which is fine, as long as contact information is provided for those who happen upon the site and want to get in touch with you.

Four Reasons Why You Should Have a Web Site

Don't be confused by all the media hype about e-commerce. Even if you have no gizmos to sell, the Internet can be a powerful tool to get the word out and to increase your visibility. A Web site is not the ultimate marketing tool, but it is an essential one in our digital economy, particularly if you work in the visual communications industry. If you don't have a Web site yet, here are four reasons why you should:

1. A Web site can give you instant credibility. Because anyone anywhere can put up a Web site, you must use yours to establish your credibility. A list of clients, some examples of your work and your contact information will show online prospects why they can trust you.
2. A Web site provides access anytime to you and examples of your work. Prospects can go straight to your Web site and get the information they need when they need it.
3. A Web site shows that you're current and up-to-date. It is essential that you have either a Web site with your own domain name, or at the very least, an online presence where your online portfolio is posted.
4. A Web site expands your exposure and increases your visibility worldwide. That means your potential market is bigger than it has ever been before because people with whom it was once difficult to communicate are now just a click away.

Design Your Site for Your Visitor, Not For Yourself

One of the main principles of self-promotion is this: self-promotion is not about you; it's about your clients and prospective clients. Your marketing materials should offer your solutions to their problems, and that applies to your Web site. So instead of focusing all your attention on how to show your work in the best light, put yourself in the shoes of your prospects and think about their moment of need for your services. Ask yourself, "When they visit my site, how do they need to learn more about my work in order to trust that I can do what they need done?"

Take a moment with the following example and think about your prospect's moment of need. Word has just come down from the president's office to George Q. Prospect, Director of Corporate Communications for ABC Corporation, that he is now responsible for revamping the company's corporate identity—and right away. That's a big project that will immediately take precedence over everything else that's cluttering up George's desk. George needs help. Where can he turn? Whom does he know? Maybe he's done all his graphic design in-house and has never used an outside resource before. Or maybe he wasn't happy with the design firm he worked with in the past. Or maybe he needs someone who specializes in his industry. Where does he begin looking?

If George is organized, he may go directly to that file he created expressly for the samples he's always telling designers to send him. And if Denise Design did that, it's possible her materials, although maybe out of date, are in there. But George is probably not so organized. Already his plate is overflowing, and he's slightly overwhelmed by this new project. In fact, he's probably sitting at his desk right now, trying hard to think about what to do next.

What Your Prospects Want From Your Web Site

Some of your prospects are visually oriented, and some are not. Some are Web savvy, and some are not. Some know what they're talking about when they use Internet jargon, and some haven't a clue. And yet, every one of them has an opinion and a perspective that matters. Here's what your clients are looking for when they visit your Web site:

- **Lots of design work.** When your prospects are in their moment of need, they want to see as much work as possible. And they want to see the quality of your work before they decide to invest the time to make contact.
- **Creativity.** Though it's very subjective, clients want creativity from the creative professionals they hire. Anything different or unusual—not boring or "industrial"—will make them stop and take notice.
- **Strategy.** Creativity alone isn't enough. Prospects also want to see your marketing savvy. Use your Web site to show how your work will help them build their business.
- **Good information architecture.** Your prospects don't have time to figure out your Web site, so make it easy to navigate and understand.

Now what if George suddenly focuses his attention on an orange card sticking out of that pile, and the color is so bright it takes him out of his paralytic reverie. He pulls it out and looks at it. It's the most recent promotional postcard from Denise Design, complete with her URL. It's exactly what he needs! Filled with adrenaline, George goes directly to the computer and punches in www.denisedesign.com.

Now continue to imagine George's experience. He's seen a lot of Web sites, but this is his first time to the Denise Design Web site. Whether he's a veteran or amateur clicker, this online experience has to be a positive one. It must ease him toward the next critical step in the marketing process: picking up the phone or clicking on the right button to send an E-mail message that says, "I have a project. Let's talk."

A Web Site Must Be More Than Pretty Pictures

"Lots of designers and artists have really cool Web sites, but most sites don't work from a marketing point of view," says Linda Fisher, president of Design Management Resources, a business consulting firm for strategic branding and graphic design firms. In other words, many designer sites convey the message "This is the Web site of an artist." Most are snazzy as can be, image coming before purpose, while the clients' needs are not addressed at all.

If you want your Web site to be an effective marketing tool, it must be designed with the needs of your clients and prospects in mind. It must say: "This is the Web site of creative professionals who can help you solve your problems."

The Web site of the world-renowned design firm Pentagram (www.pentagram.com) does just that. Building on their name recognition and publicity, the current Pentagram Web site, designed by Pentagram associate James Anderson, is built for ease of use as a selling tool. It's geared towards showing off their work in an accessible way. "Our Web strategy is to get our work in front of potential clients as quickly as possible," says Kurt Koepfle, communications manager at Pentagram Design in New York. "The site is about holding their interest long enough to take the next step and get in touch with us."

Who We Are ●
Ideas ●
● Home
●
● Exchange

What We Do

Recent Work Clients Pentagram Publications Site Index

We offer design services in the following areas and welcome assignments that require a mix of these capabilities

Graphic Design

We create any and all of the visual facets of an organization related to the projection of its identity: printed and on-screen communications, technical and promotional information; publications for products, sales and finance; books, magazines and newspapers; the form and labeling of packaging; and integrated sign systems and environmental graphics.
Recent Work

Industrial Design

The design and development of products, merchandise, packaging and equipment for domestic, commercial and industrial use and consumption: conceptualization and model-making; definition of production details and processes; and research and management of manufacturing and marketing resources.
Recent Work

Architecture

The structural and interior design of public, commercial and residential environments: spaces for business, retail and public facilities; restoration and renovation of interiors and buildings; and the design of furniture, fixtures, retail displays, stage sets, and exhibitions promoting trade and cultural events.
Recent Work

The "What We Do" page from the Pentagram site (www.pentagram.com) clearly and concisely describes their three design specialties.

tip *How to Choose a Web Address*

Your Web address (or URL) must be short, easy to spell, understandable and intuitive. If possible, it should be what your prospect would guess it would be. It can be as simple as the name of your firm, such as www.topdesign.com, or, if you work independently, your name, like www.jedblock.com. Be sure to test the site name verbally before you register it, because sometimes a URL that looks great on paper causes confusion when spoken, which can result in misspelling, which means it won't be found.

chapter 2

web site as a simple online portfolio

The online portfolio has added a new step to the process of choosing a design firm or illustrator, a step that comes at the very beginning of the getting-to-know-you period and makes everyone's life—yours and your prospect's—easier and more efficient. Your prospects can go to your Web site and check you out before making contact, because even a simple online portfolio allows you to convey so much more about yourself and your services than the few examples of your work they'd find in a creative directory. The goal of your simple online portfolio, then, is to provide enough of a taste of your work for a prospect to decide whether to take the next step: making contact.

"A design firm's Web site gives you an idea whether you want to touch and feel and make the connection." That's the perspective of Audrey Sumberg, creative director at Internet-based market research provider Harris Interactive. "The Web gives me the ability to have confidence in a designer's work before I walk through the door."

Though not a substitute for your offline portfolio, an online portfolio is a very effective marketing tool, especially if it will answer these simple questions: (1) Does your style fit what your prospects are looking for? and (2) Do you have the experience to do what they need? In this chapter, we'll focus on three different strategies used by creative professionals to convey information about their work through simple online portfolios.

> *"Years ago I pleaded with art directors to go to my Web site, but they were only interested in my portfolio. Now they only want my Web address. My portfolio has not seen the light of day in well over a year."*
>
> **Bud Peen, illustrator**
> **(www.budpeen.com)**

"The sketchbook metaphor shows that we are graphic artists. Plus, people like that it's something recognizable."

Christy McElligott,
McElligott Graphics
(www.mcegraphics.com)

When your online prospects arrive at your Web site, the first thing they need to know is how to find the samples of your work. The easier a Web site is to understand and navigate, the longer visitors will stay. And the more they see of your work, the more they'll get to know your work.

One strategy that helps to orient visitors quickly is to use a metaphorical interface that is familiar and intuitive. The Web site for McElligott Graphics uses the image of an artist's sketchbook to present their design and illustration. Matt and Christy McElligott, partners at home as well as at work, use the sketchbook metaphor to communicate that they are graphic artists. Their clients get the message. "You look at it and you get the image of what McElligott Graphics is all about," says Sue Marshall of MicroKnowledge, Inc., a computer training company in Albany, New York, who hired McElligott Graphics to design their corporate Web site.

The Simplest Web Site Must Have at Least . . .

1. **Biographical Information.** Call it what you want—"Profile," "About Us" or "Who We Are"—but provide information about yourself and your firm. In order to trust you, your visitors need to know about the people behind your Web site. In fact, many people refuse to do business with a company that doesn't make this information available.
2. **Online Portfolio.** Your visitors will, first and foremost, be looking for examples of your work and information about your clients. So give them a lot to look at, and organize it in a simple way.
3. **Contact Information.** Visitors will need to know how to contact you, so make it easy for them. Give them many options—phone (toll free, too!), fax, E-mail, snail mail—and make that information accessible from every page of your site.

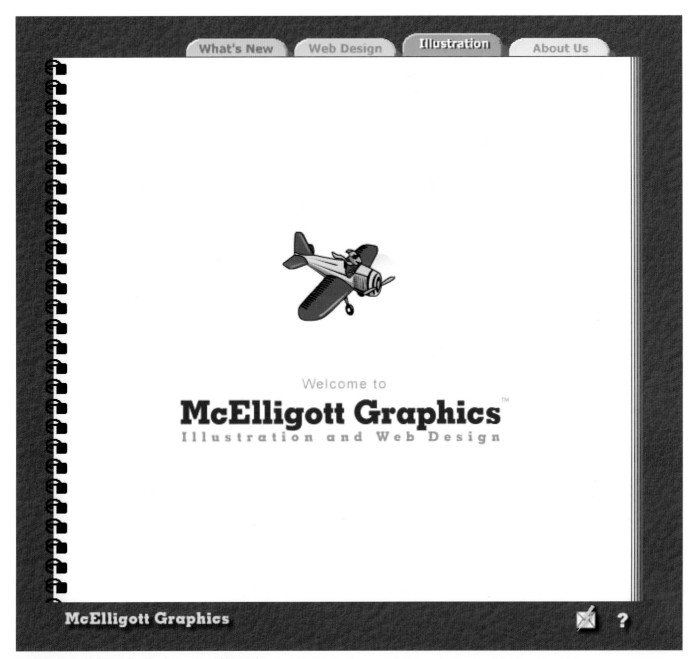

The Web site for McElligott Graphics (www.mcegraphics.com)
uses the image of an artist's sketchbook to present their
design and illustration.

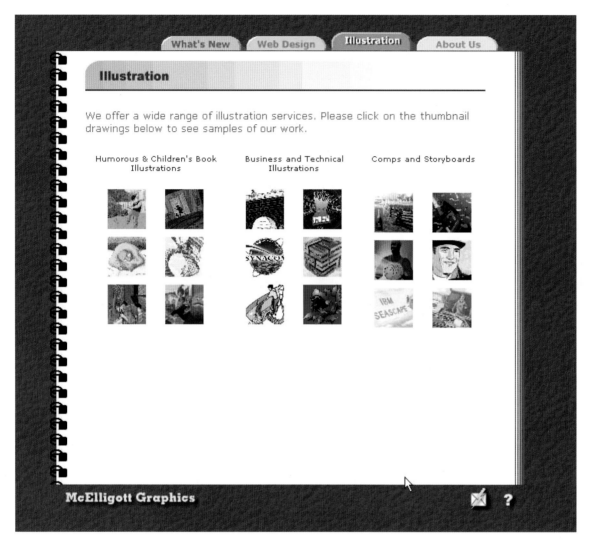

Marshall especially liked the sample Web sites she accessed through their site. "Their samples let me see what they're capable of," she says, "plus gave me ideas for our own Web site." McElligott Graphics's site is not a fancy site; there are no bells or whistles, and just a little animation. You know right away you won't be getting lost in a jungle of pages. The main frame, which is the sketchbook, contains all the visuals and is set in the middle of the screen so that no scrolling is necessary. Four tabs across the top represent the four main destinations: "What's New," "Web Design," "Illustration" and "About Us."

Each of the four destinations offers a blurb of explanatory text and several links to examples of the work. Under "Illustration," for example, visi-

tors find a brief statement about their illustration work, followed by samples in three categories: "Humorous and Children's Book Illustrations," "Business and Technical Illustrations" and "Comps and Storyboards." In each category are six thumbnail drawings, which link to a closer view with a one-line description of the actual project. Likewise, the "Web Design" tab has a bit of descriptive text and links to six sample Web sites.

Although an online portfolio is often not enough for a client to make a major decision like this, MicroKnowledge's Marshall acknowledged that the simplicity of the sketchbook metaphor made the decision-making process that much easier, and McElligott Graphics got the job.

McElligott Graphics's Marketing Tool Kit

Offline marketing tools are essential to your overall marketing efforts. Here is what McElligott Graphics uses to complement their online marketing:

- Advertising
- Direct Mail
- Networking

Because most of their work is done for clients in the Albany, New York, area, McElligott Graphics advertises their services in Ad Facs, a local directory of marketing resources, which generates a lot of inquiries. Plus, for no additional fee, McElligott Graphics gets a link from the companion Web site for the printed directory (www.adfacs.com) to their Web site. They also advertise nationally in the Graphic Artists Guild's Directory of Illustration and send out direct mail postcards to children's book art buyers culled from the *Children's Writer's & Illustrator's Market.*

In addition, being involved in the community keeps their visibility high. Matt McElligott, who is also a children's book author, does author visits at local schools and serves as president of the Albany chapter of the Graphic Artists Guild (www.gag.org/albany). Says Matt, "Being active has been essential for promoting myself locally. Albany's a pretty small market, and I've developed some great contacts (and friendships) through networking."

The printed promotional materials for McElligott Graphics complement their Web site.

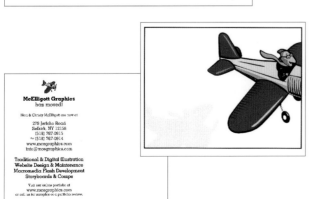

"We don't want to overdo it, so the work on our Web site is focused on the entertainment industry, which is our target market."

Peleg Top,
Top Design Studio
(www.topdesign.com)

You're probably capable of doing just about any kind of design work that your clients may need, but that doesn't mean you have to show it all on your Web site. In fact, a Web site is a good place to focus on your ideal projects in an effort to attract more of those ideal clients. This is the strategy behind the Web site for Los Angeles-based Top Design Studio. The firm's site is designed to get them more of the work they love: print and packaging projects in the entertainment industry.

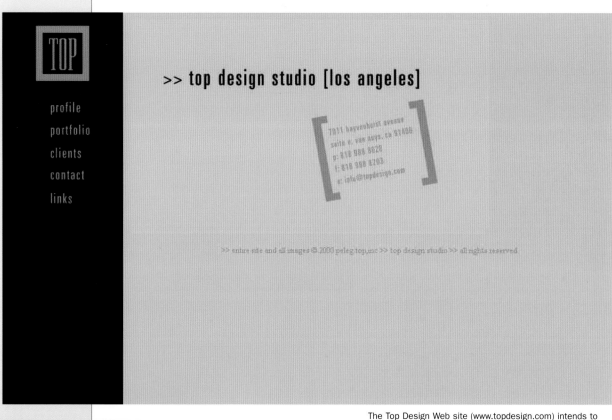

TOP

profile
portfolio
clients
contact
links

>> top design studio [los angeles]

7011 bayvenburst avenue
suite r, van nuys, ca 91406
p: 818 980 8020
f: 818 980 8203
e: info@topdesign.com

The Top Design Web site (www.topdesign.com) intends to whet the appetite of its visitors and encourage them to request more samples.

To Splash or Not to Splash

First impressions count. In Web terms, that means the first look a user takes at your Web site is going to have a strong impact. If your Web site has a splash page—that introductory page that acts as a ceremonial front door—consider this: The first thing you are asking your visitor to do is stop and think about whether they really want to enter.

If someone has typed in your URL or clicked on a link to your site, they probably want to see it. If you delay them, they may change their mind. So either forget about a splash page and lead your prospects directly to what they're looking for, or, if you must have a splash page, make sure the page automatically forwards to the place where the real information is located, so a visitor doesn't have to do any extra clicking or decision making.

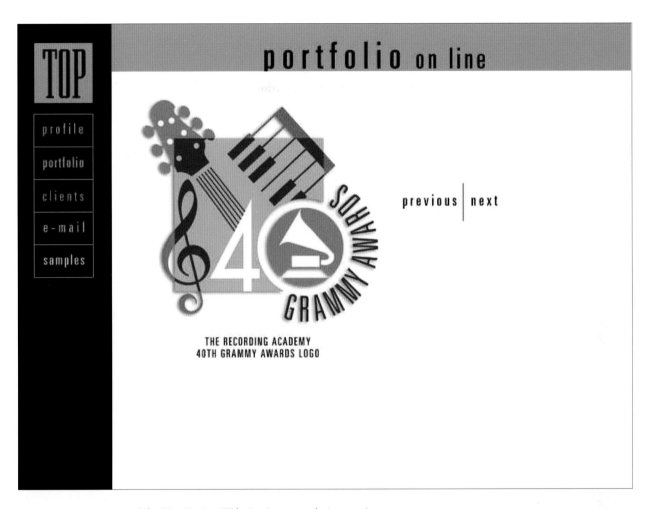

portfolio on line

TOP

profile
portfolio
clients
e-mail
samples

previous | next

THE RECORDING ACADEMY
40TH GRAMMY AWARDS LOGO

The Top Design Web site (www.topdesign.com) is intended to whet the appetite of its visitors. The home page offers on a left-hand navigation bar five main destinations: "profile," "portfolio," "clients," "contact" and "links."

"Profile" has a short description of the firm and its founder, with reinforcement of the focus on the entertainment industry. The "clients" page aims to impress and inspire confidence by listing some of the big names the studio has worked with, such as Quincy Jones Productions, Columbia Tri Star, Windham Hill Records, the Rock and Roll Hall of Fame and Museum, and The Recording Academy.

The portfolio section of the Top Design Web site is a linear slide show of selected projects for the entertainment industry.

The "portfolio" section opens with a list of the media in which Top Design works, including CD packaging, logos, posters, invitations, title treatments and Web design. From there, a visitor clicks through a linear progression of twenty-two, quick down-loading images, just enough work to see the full range of Top Design Studio's experience without requiring the structure of categories and without asking visitors to commit too much time.

The Top Design Web site is designed to mirror their offline portfolio. "We want the experience to be like flipping through our portfolio," says Peleg Top, principal and founder of the firm. "If that speaks to them, they will pick up the phone and ask for samples." And they do. When an executive from Universal Records in New York recently saw the Top Design Web address (or credit link) on a CD package they had done, he went directly to the Web site, and sent a message through the E-mail link. The message simply said, "Please call me," and gave his name and phone number. "I happened to be online at the time," says Top, "so when I got the message and saw that it was from a record company we wanted to work with, I called him right away. He was still looking at our Web site when my call came through, and he was totally impressed that within five minutes of logging onto the site, he had me in person on the phone. I never would have known this person existed if he hadn't found our Web site." Once the connection was made, Top Design went through the rest of the process offline and landed the job.

Thanks again to a credit link—this one on the first Web site they designed—Top got another

high-profile assignment: the packaging, advertising and promotional campaign for Patti LuPone's CD release. "Patti's people saw our credit link on the site we designed for another performing artist, Lypsinka (www.lypsinka.com)," says Top, "so they went to our Web site to see more of our work. It was enough for them to be convinced that they wanted us for the project. Once the numbers looked good, we signed the contract and went to work."

[*definition*]

What's a Credit Link?

A credit link is a credit line displayed on the work you do for your client, but instead of the usual "Design by Top Design," your Web address is displayed. If the credit link is on a Web page, it actually links to your Web site, bringing interested prospects into direct and immediate contact in their "moment of need."

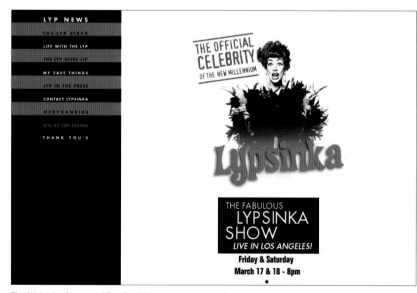

The Web site for one of Top Design's clients, the performing artist Lypsinka (www.lypsinka.com), has a credit link to www.topdesign.com, which stimulates a lot of inquiries for Top Design Studio.

Top Design's Marketing Tool Kit

In addition to their industry-focused Web site, Top Design uses a lot of offline marketing to keep their visibility high, which is especially important in the entertainment industry. They accomplish this through direct mail, speaking engagements and networking.

Since 1993, Top Design has been sending a monthly calendar to an in-house mailing list of prospects, inquiries, referrals, clients and vendors— basically everyone they know. Peleg Top is also very active in the graphic design community as a speaker at conferences and through his work as president of the Southern California chapter of the Graphic Artists Guild (www.gag.org/southcal).

Says Top, "This kind of participation not only provides a sense of prestige that opens doors, it's a good way to meet prospects." In fact, he was on a panel on the topic of breaking into the record industry at the 1999 HOW Design Conference with the art director from Arista Records, who has since become a major client of the firm.

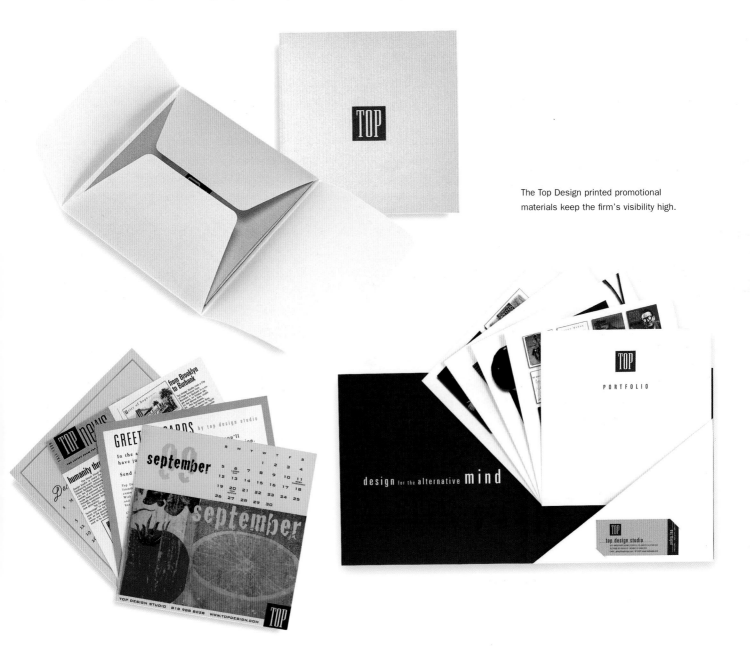

The Top Design printed promotional materials keep the firm's visibility high.

Logging on to Jed Block's Web site (www.jed-block.com) is a multimedia experience. No, he doesn't use Flash or plug-ins or anything fancy. Instead, from deep within the computer comes the strum of a banjo playing a song that you know: the theme song from *The Beverly Hillbillies*. And visitors see a picture of Jed (Block, not Clampett, that is), with a winter coat over his bathrobe, java in hand, with the caption "The writer prepared to work…"

While Block offers his resume and the business samples that his prospects are looking for, it's the personal nature of Block's Web site that sets it apart and makes people slow down their surfing, which is his intention. "I use my Web site to offer a little humor, creativity and substance. I like to think my approach differentiates me as a writer and adds some personality and humanity to the site." This is an important point because many people won't do business with a company whose Web site doesn't provide any information about the people behind the site. Block takes this personal side a little further than many creatives do by including poetry and essays about life with his family. But if the comments and E-mail messages he gets from prospects and clients are any gauge, his strategy seems to be working. Here are just a few of the messages he's received about his site:

- Hey Jed, I surfed your Web site. Great stuff. Loaded fast. I admire your writing; it's comfortable and conversational, easy to read. Thanks for sharing.
- Jed, I just wanted to let you know that I had no idea how multitalented you are. I thoroughly enjoyed the Web site, particularly your stories. Keep up the good work.

"I like to think that the tone of my site provides some relief from the rush, clichés and boredom too often associated with business," says Block. "I receive quite a bit of positive feedback just because the stuff that appears on my site isn't normally part of a business site." And that's what makes him stand out and be remembered.

B·L·O·C·K
WRITER • PHOTOJOURNALIST
COMMUNICATIONS STRATEGIST

Come listen to some
stories by a man named Jed
poor, lonely writer
barely keeps his family fed...

CONTENTS

• Makes silk purses from sows' ears (resume)

• Bubblin' crude (business samples)

• Children's book about diabetes
(swimmin' pools, movie stars?)

• Letters he's written, never meaning to send
(some personal stuff)

• Send him e-mail

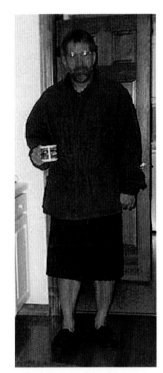

The writer prepared to work:
Jed Block writes for
businesses and people
wanting to communicate
clear, stimulating,
professional information with
others.

**Click here to enter Beverly _(Hills, that is)_
and see a current piece of work**

The home page of writer and photojournalist Jed Block's Web
site (www.jedblock.com) plays the theme song from _The
Beverly Hillbillies._

chapt

chapter 3

The Contact Sheet

Who We Are

er.3

web site as a showcase of projects and process

You probably assume (or hope) that if prospects are really interested in working with you, they will spend some quality time on your Web site. But that is often not the case. In fact, many prospects don't spend much time at all at a Web site. According to David Curry, of New York-based David Curry Design, "If you really want them to see something, you've got to give them a direct link to a specific page; and even then, you can't be sure they'll go there."

Of course, it makes perfect sense that your prospects don't spend as much time on your Web site as you'd like them to—most have very little time in the first place. Plus, the Internet is a quick-clicking medium that encourages skimming and scanning rather than careful consideration and real reading. This should affect the strategy behind your Web site design. Your Web site should make it easy for those with little time to find what they're looking for fast, and it should offer additional details and information for those who want to browse leisurely. The degree of detail you offer about your process, your clients and your personality is up to you. The most important thing is to make sure the information is organized well and presented in such a way that it's easy for prospects to get more, if they want it.

The four design firms' Web sites in this chapter offer varying amounts of information through four different strategies—from clean and simple, with just a few details, to more complex (though often still clean), allowing visitors to drill down to get more details with each click.

"Some Web surfers want lots of details, so offer condensed overviews with links to more complete information—that way casual viewers aren't bored by details, but the details should always be available. Not only will this help your visitors, it will help you, because you'll spend less of your time answering questions people might not ask if you had it [the information] on your site."

Daniel Will-Harris, editor in chief, eFUSE.com, "the friendly place to learn how to build a better Web site" (www.efuse.com)

"We're promoting to the world, which is a very diverse audience, so we wanted to be brief, invite questions and present the work in a very simple, clean format."

Don Sibley,
Sibley Peteet Design
(www.spddallas.com)

From the very top of the home page of the Sibley Peteet Design Web site (www.spddallas.com), a short blurb summarizes the firm, highlights their expertise and offers a clear overview of the contents of the site. Not only does this make it easy for a visitor to understand where they've landed, this introductory text makes it easy for search engine spiders to find and index their site.

S P

Sibley Peteet
DESIGN

Welcome. We are a strategic marketing and communications firm that leverages the power of design to influence consumers.

Over the past seventeen years, we have helped companies develop branding and collateral that express who they are, what they do, and why people should do business with them.

Who We Are

What We Do

What's New

The home page of the Web site for Sibley Peteet Design (www.spddallas.com) makes it easy for a visitor to understand what the site offers.

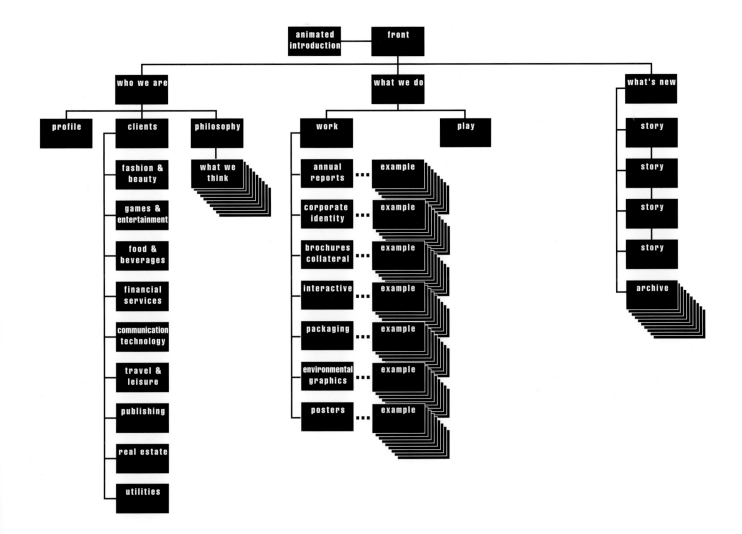

The site map of the Sibley Peteet Web site shows that none of the information is buried too deep.

The flowchart for the Sibley Peteet Design Web site shows how close to the surface all the information is; despite its 250 pages, nothing is buried too deeply. "Our tracking reports show that most people take the time and go through our site, and we get comments on how simple it is to navigate," says Don Sibley, the firm's principal.

Under "Who We Are," the "Clients" page lists ten categories, reflecting the variety of industries which Sibley Peteet serves, from Fashion and Beauty to Utilities. This list demonstrates that, like many design firms, their experience is vast; and though they don't specialize in any one industry, they show enough work in each category to make prospects comfortable.

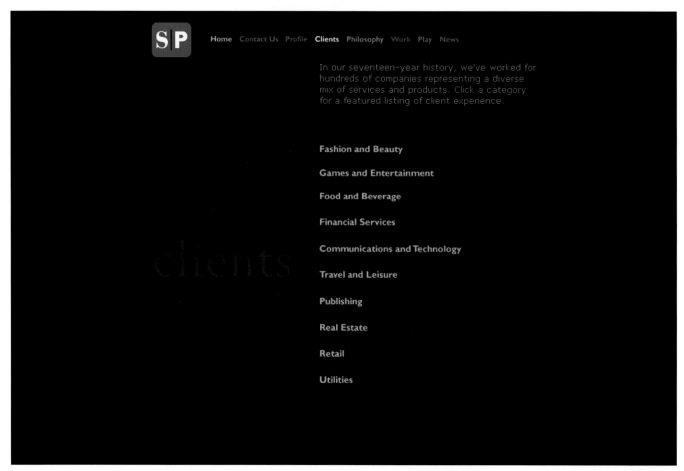

The "Clients" page of the Sibley Peteet Design site organizes their samples by industry.

Each category lists clients Sibley Peteet Design has worked with in that industry.

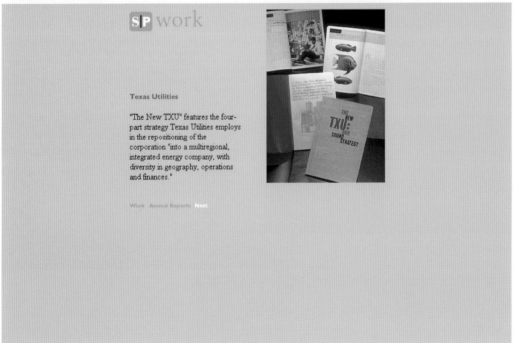

Detail of a project from the Sibley Peteet Design Web site.

Each of the ten categories has its own page listing several clients—some of whom are pretty high profile, such as Nike, Milton Bradley and The Dixie Chicks—where visitors can see examples of the work. Clicking further leads a visitor to a photograph with a one-line explanation of the project.

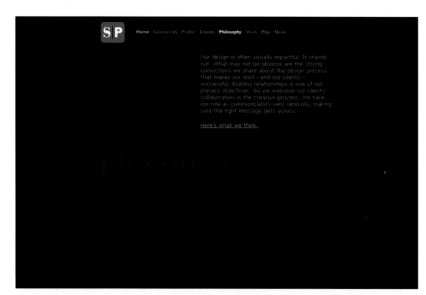

The "Philosophy" section from the Web site of Sibley Peteet
Design offers a slide show of pithy sayings.

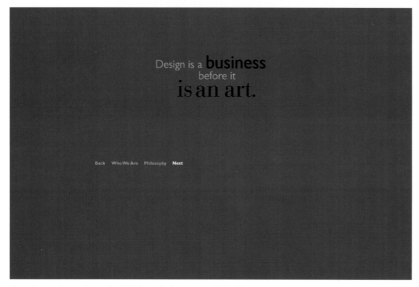

Here is one frame from the "Philosophy" section of the Web
site of Sibley Peteet Design.

The firm's "Philosophy" section begins with a
brief summary and the linking text "Here's what we
think," for those who want to know more. Ten
screens follow, a slide show of sorts, with pithy,
one-sentence aphorisms, such as "Design is a busi-
ness before it is an art" and "Simplicity is the key
to effective communication."

According to Brent McMahan, Sibley Peteet's
vice president of New Media (a.k.a. their Web
guy), their Web tracking reports indicate that it's
one of the highest-hit sections, which proves that it
is important to prospects to get to know the people
they are considering working with.

From the "What We Do" section, there are two
simple choices: Work and Play. Under "Work" is a
list of media—including Annual Reports;
Corporate Identities/Logos; Brochures, Collateral,
Etc.; Interactive; Packaging; Environmental
Graphics; and Posters—again showing a wide range
of expertise. This organization by media allows
prospects looking for annual reports, for example,
to be able to find several examples easily. And just
like in the "Clients" section, each medium offers a
list of clickable clients, with photographs and one-
liner descriptions.

The "Play" category shows a little personality—
just enough to convey that Sibley Peteet staffers are
not always serious—which helps form a human
connection with the company. This is key when it
comes to online marketing because it helps to
establish the comfort, familiarity and trust that
otherwise comes through face-to-face contact.
Here, visitors will find a blurb with a photo of
Sibley Peteet employees on their annual summer
retreat, this one to Santa Fe, New Mexico.

*"Biographies and photographs
help make the Web a less
impersonal place and increase
trust. Personality and point
of view often win over
anonymous bits."*

**Jakob Nielsen, Web Usability
Guru (www.useit.com)**

People can be easily confused when surfing the Web, especially busy people. Here are a few tips on how to write navigation buttons that encourage visitors to explore further, rather than click away.

1. Follow the standards that appear to exist. There is no definitive standard, so check out how your competition and your colleagues are directing visitors to the inner pages of their Web sites, and follow their examples.

2. Use words that are familiar. People understand conventions—such as Portfolio, About Us and Contact Us—and find them easy to use. This isn't the place to be too creative (and potentially confusing).

3. Offer both text and image buttons. If you use only images, your visitors may not be willing to spend time waiting for them to download just to find out what the page offers. They also may not understand what the image or icon refers to.

Like the Web site, the printed promotional materials for Sibley Peteet Design are organized by media.

Sibley Peteet Design's Marketing Tool Kit

Besides the Web site, Sibley Peteet uses many other marketing tools to spread the word about their services, such as printed promotional materials, direct mail and publicity pieces. Spiral-bound miniportfolios showcase each of the firm's four main specialties—annual reports, corporate identity, packaging and interactive—reinforcing their expertise in each medium. They also send to their in-house list direct mail that highlights each medium. Plus, the firm's work has been published in design annuals of *Communication Arts*, *Graphis*, *Print* and the *Art Directors Club Annual*, which often generates interest and inquiries from key prospects, who then are added to the in-house mailing list.

SIBLEY PETEET DESIGN

0 PACKAGING 1

SIBLEY PETEET DESIGN

BRENT McMAHAN

3232 McKINNEY, SUITE 1200
DALLAS, TEXAS 75204
214-969-1050 FAX 214-969-7585
brent@spddallas.com

AUSTIN 512-473-2333 FAX 512-473-2431

"Clients tell us that we are one of the only firms that speak their language and demonstrate that our work is result-oriented."

Frankfurt Balkind
(www.frankfurtbalkind.com)

Frankfurt Balkind is a large branding and design firm with three offices around the United States, and many areas of expertise. The nine categories listed on the "Clients and Services" page of their Web site (www.frankfurtbalkind.com) range from "Strategic Positioning" through "Direct Marketing" and "Entertainment Marketing" to "New Media," which includes "Web Site Development" and "Kiosks."

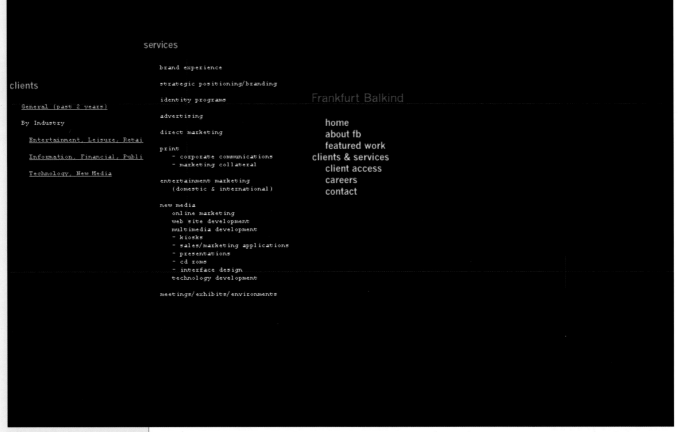

There are nine categories listed on the "Clients and Services" page of the Frankfurt Balkind Web site (www.frank-furtbalkind.com), showing a wide range of services offered and industries served.

Frankfurt Balkind's online marketing strategy is to use the Web to show visitors the breadth of the services they offer. On their site they post examples of projects the firm has done for well-known (and well-respected) clients, which lends credibility to their expertise. But that's not all: Frankfurt Balkind's intention is also to demonstrate their ability to get results for their clients. This sets them apart from other design and communication firms, which tend to present only the end-product—what they designed or created—of a project, but no information about the effect of the work, such as response, sales increases or other bottom-line statistics.

Results are of the utmost importance to clients and the Frankfurt Balkind Web site presents this information through case studies, with clear and concise descriptions for each project, including their strategy and recommendations, plus the results achieved.

Adding results-oriented description to the projects you show on your Web site will give you a marketing advantage. It will demonstrate your understanding not only for "the visuals," but also for the bottom line.

"To sites that bury their content, I have one thing to say: Don't put the milk in the back of the store. This is what grocery stores do in order to get you to walk by cookies and other temptations. It doesn't work so well on the Web. People like to pluck the delectables from your site and move on."

Larry Chase, *Essential Business for the Net* (www.larrychase.com)

KPMG: Creating a Magazine to Impact Global Perceptions

Big 6 accounting and consulting firm KPMG Peat Marwick wanted to continue to broaden its business with an elite global audience. They opted to publish a magazine, independent of KPMG, that filled a void for global business information. Our challenge was first to help strategically position the magazine, and then to work with the editor-in-chief to bring the content to life. As a separate assignment, we created KPMG advertising inserts for each magazine and advertising for the magazine launch.

KPMG had been interested in reviving the name "World," the title of an earlier corporate magazine. Our naming recommendation was "Worldbusiness," with a subtitle "The Global Perspective," which more directly communicated that this was a vital tool for business and government leaders operating in an international marketplace.

We developed an enduring format for *Worldbusiness* that combines classic and urbane style with modern graphics. From the photojournalistic cover to the clearly delineated departments for world news, to the use of contemporary illustrations, *Worldbusiness* looks quite distinct from publications such as *The Economist*, *Forbes* and *Fortune*, yet it carries the same kind of journalistic weight and is deep in content.

In order to keep from diminishing the magazine's editorial credibility, KPMG advertising was excluded from its pages. Promotion of the company and its services instead took the form of an eight-page advertising insert, which we created. The magazine launch was supported by direct response ads we developed that ran in both *The New York Times* and *The Wall Street Journal*.

The first day *The New York Times* ad appeared, KPMG received more than 300 faxed requests (their machine broke down) and more than 200 toll-free telephone responses from people seeking the magazine. A second ad in *The Wall Street Journal* pulled the same response. Due to positive response, KPMG will publish *Worldbusiness* bimonthly rather than quarterly and will accept advertising from prestige companies.

Source: www.frankfurtbalkind.com

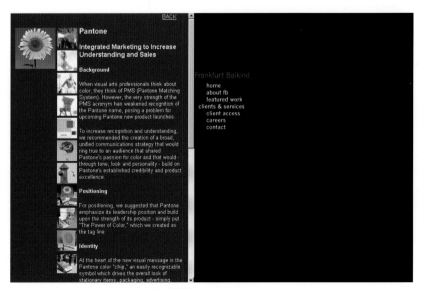

The case study for the consulting firm KPMG shows images of the finished product, as well as text describing the strategy and results.

"We mean for the Web site to be a visual experience. We want our prospects to focus on our Web site and get turned on by the work."

**David Curry,
David Curry Design
(www.davidcurrydesign.com)**

The David Curry Design (DCD) Web site offers a detail-oriented approach to showing the work. From the home page of their Web site, a visitor can either choose from four categories—"Graphic Design," "Web Site Design," "Photography" or "Clients"—or take a tour through "Anatomy of a Web Site Design," a graphic description of the Web design process.

The project showcased in the "Anatomy" section is a Web site for Compware, a United Kingdom-based software company, and their premier product line, Agile Web Authoring Tools. With copy written by David Curry, "Anatomy" demonstrates the

step-by-step process of designing a Web site. It begins with "Phase 10: Planning" and continues through nine screens of text and images which describe the objectives and elements of the process, ending with "Phase 5: Supervision," where a testimonial from their satisfied client is posted, plus a link to the new site.

According to WebTrends site analysis software, which tracks user profiles and site usage, "Anatomy" is one of the top ten features on the site. Plus, the client, Compware, loves it and has it linked (or connected) to Web sites all over Europe, which means additional exposure for DCD. And

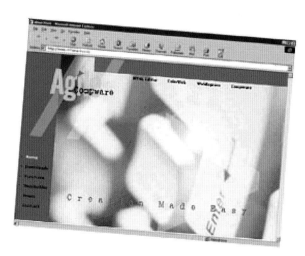

David Curry Design

On Time and Within Budget

▶ **Anatomy of a Web Site Design**
A Step-By-Step Guide

▶ **Graphic Design** ▶ **Web Site Design** ▶ **Photography** ▶ **Clients**

[Sitemap] [Profiles/Free Clipart] [Web Optimizer] [Links] [Contact]

Copyright ©1998 David Curry Design

The Contact Sheet ◆ New York 212.579.7560

The home page of the Web site for David Curry Design (www.davidcurrydesign.com) offers the step-by-step "Anatomy of a Web Site Design."

Anatomy of a Design Project

Agile Web Authoring Tools
Compware, UK

David Curry Design ◆ New York 212.579.7560

Phase 5: Supervision

Public Site Launch
Site Promotion
Site Usage Analysis
Site Content Replenishment

The Compware web site was launched in May and has become an instant success. Mark Hughes, the proprietor, responded by saying "Well, what can I say? You promised to blow me away and you have. It is superb. Naturally, I disagree with you though about..." A true client to the very end!

One of the most unique aspects of the client relationship is that we have never met, nor talked on the phone and hardly used the post office. Mark works in Cambridge in the UK and we're based in New York. The site design program

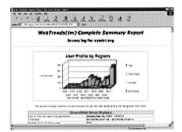

Web Trends Site Analysis

while not all visitors will take the time to go through all nine screens, it almost doesn't matter; the fact that DCD offers a close look at the Web design process positions them as experts on the topic, thereby increasing their credibility. "The site itself is an example of what we can do," says Curry. "It validates our capabilities and saves a lot of time doing presentations."

This strategy is sometimes referred to as "design defense," as if showing the process defends against those who think there's nothing to it. But there is a definite benefit to demonstrating the depth of your knowledge on a particular topic. The DCD site

shows, in a simple and understandable way, that Web design is a complex process that requires special skills. Not only does this kind of feature facilitate an understanding and appreciation of the design process, it also can educate your market about a medium that is still new and constantly changing.

[*resource* **]**

Web Trends Site Analysis Software
www.webtrends.com
(503) 294–7025

"Anatomy of a Web Site Design" demonstrates the process of David Curry Design.

"Our Web site is intended to put a positive public face on the work we've done and to show our knowledge. The focus on content is our way of saying that we are more than just a typical design shop."

**Andy Austin,
director of communications,
watersdesign.com
(www.watersdesign.com)**

The watersdesign.com brand carries through everything from their printed materials to their office space.

If you have a name like John Waters (no, he's not the film director), you can't help but play on the words, and that's exactly what John Waters has been doing since he started his design firm in 1977. In fact, he's turned his name into a registered trademark: The Waters Edge. This identity is reflected everywhere you look, from the blue folder of the firm's marketing kit to the decor of their office space to their Web site, www.watersdesign.com, where the Webmaster is called a "harbormaster."

In January 1999, the firm changed its name from Waters Design Associates, Inc. to watersdesign.com because John Waters believes that interactive business is the wave of future and he intends to ride that wave. (Excuse the metaphor, but because John Waters has done such a thorough branding job, it's impossible not to use it). He wants everyone who comes into contact with the company to think in terms of water and the layers of meaning built into The Waters Edge: the fact that they're literally at the water's edge at the tip of Manhattan and that working with Waters would give any client an edge.

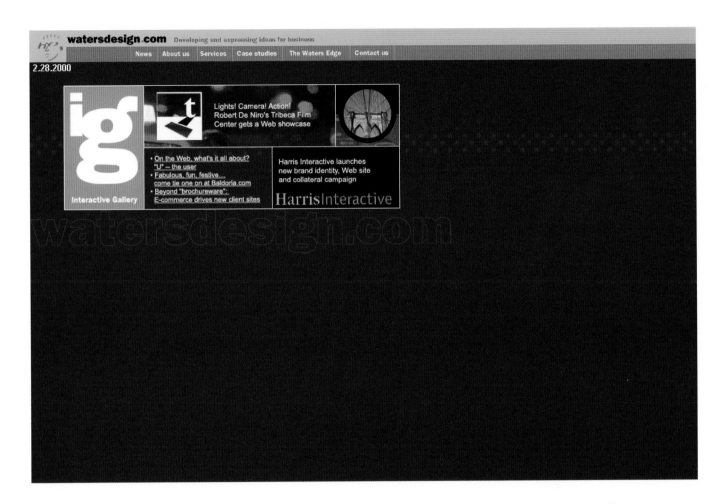

The watersdesign.com home page.

Because their focus is on interactive business, their Web site basically serves as one huge portfolio. "Our site is a reflection of our approach to clean design that supports the site's content and purposes," says Andy Austin, director of communications for watersdesign.com. Instead of providing a separate portfolio section on the site where all the work samples can be found (a simple and common strategy for designers), the examples of actual design work are woven throughout the site. So while "The Interactive Gallery" shows off recent Web site design and development projects, links to client work can be found embedded in the text of press releases in the "News" section. And in the "Services" section, blurbs about branding and e-commerce services lead straight to more examples and case studies. This makes for a more intuitive approach to showing the work, though also for more complex navigation.

Rather than being visually driven, the watersdesign.com Web site is content driven and idea driven. A section of the site entitled "The Waters Edge" is the core of that content, where articles such as "The Value of Community," "Creating Compelling Web Content" and "Personal Privacy on the Web" (all written by Austin) are designed to show off the firm's knowledge and skills, as well as educate prospects on interactive business. The content is intended to demonstrate the company's expertise, which instills a sense of trust and shows they know what they're talking about, which is a different strategy to achieve the same goal as David Curry Design.

At "The Waters Edge" section of the watersdesign.com Web site, visitors can find articles and resources on interactive business.

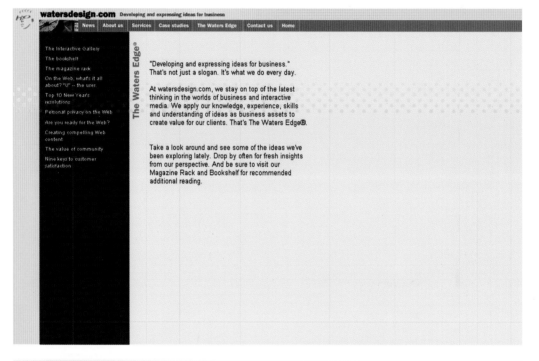

"Personal Privacy on the Web," one of the articles featured on "The Waters Edge" section of the watersdesign.com Web site.

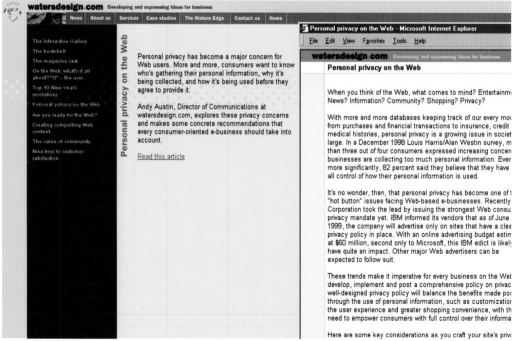

watersdesign.com Developing and expressing ideas for business

News | About us | Services | Case studies | The Waters Edge | Contact us | Home

The Interactive gallery
The bookshelf
The magazine rack
On the Web, what's it all about? "U" -- the user.
Top 10 New Year's resolutions
Personal privacy on the Web
Are you ready for the Web?
Creating compelling Web content
The value of community
Nine keys to customer satisfaction

The magazine rack

The worlds of business and interactive media are changing every day. To keep up, we read quite a few publications.

Browse our Magazine Rack to see a selection of the most thought-provoking articles we've read lately.

"It's not such a small world after all"
Dana Blankenhorn
Datamation, March 1999
They don't call it the World Wide Web for nothing. When you decide to target a global audience, translating your message into local languages is just the first step. Using Kodak's experience as an example, *Datamation* writer Dana Blankenhorn states the case for taking local tastes and cultural differences into account when crafting Web content to reach readers in other parts of the world.
Read Article

"The Big Picture"
Danny Hillis
Wired, Issue 6.01, January 1998
Where is humanity headed? Is our increasingly-networked world setting the stage for another round of evolution? Danny Hillis shares his view of the "big picture."
Read Article

"Bye-Bye"
Randall Rothenberg
Wired, Issue 6.01, January 1998
Our mass media -- newspapers, magazines, broadcasting -- are founded on the support of advertisers. Up to now, advertising has been seen as

"The Bookshelf" lists five or six carefully selected books on design and business, from *Webonomics* by Evan I. Schwartz to *The Creative Priority* by Jerry Hirshberg. "The Magazine Rack" offers more recommended reading of thought-provoking online articles from business publications such as *Fast Company* and *Datamation*. "The whole idea is to position ourselves as having an edge," says Austin. "The articles highlight the fact that we do a lot of thinking; they are meant to show that we keep up with what's going on in Web design and other Web issues."

"The Magazine Rack" links to recommended articles posted online.

section. **two**

more online

more online marketing tools

chapter 4

er.4

utilizing digital portfolio sites

Where do your prospects go? That's the big question. When your prospects need to find a creative professional, will they go looking offline or online? The answer, of course, is that it depends on what they're used to and what is convenient at the moment. They may go to "the books," those familiar but oh-so-heavy directories of creative resources, or to their own personal address books. The organized prospects may check those files where they've been stuffing promo materials for years. The busy ones may simply ruffle through their most recent pile of mail. The resourceful ones might pick up the phone to call someone who knows a lot of people. And some may search online.

Maybe they'll visit the familiar, but perhaps not most effective, search engines, like Yahoo! or AltaVista. Perhaps they'll check out the Web pages for those heavy directories or for industry associations such as AIGA or Graphic Artists Guild. Some will go directly to portfolio sites.

Posting your digital material on a portfolio site can bring clients to you who probably wouldn't have otherwise found you. And if you don't yet have your own Web site, a portfolio site can serve as an interim site so that when someone asks for your Web address, you don't have to hang your head in shame because you just haven't gotten it together yet. But whether your clients find your digital portfolio on their own or you guide them to it, you need to have a digital portfolio available somewhere in cyberspace. In this chapter, we'll look at three different portfolio strategies creative professionals use to make their work instantly accessible.

"A digital portfolio is just another tool. But, it's very effective when combined with other forms of advertising."

Roxana Villa, illustrator (www.roxanavilla.com)

Illustrator Roxana Villa has her own one-page Web site, www.roxanavilla.com, but her "official" portfolio is posted on Theispot-Showcase. There, for approximately $650 per year, she has everything she needs: a twelve-image portfolio, her bio and a contact page, through which people can send her E-mail.

[*definition*]

What Is a Digital Portfolio?

A digital portfolio displays samples of your work online at sites such as your own Web site, the Web sites of trade groups (such as the Graphic Artists Guild [www.gag.org]) or on portfolio sites (such as www.workbook.com or www.Theispot-Showcase.com).

Villa, who's been in business for fourteen years and whose colorful illustrations have been commissioned by corporations such as Siemens and Simon and Schuster and major media outlets from *The New York Times* to *Sports Illustrated,* has found posting her portfolio on Theispot-Showcase to be phenomenally effective. Her digital portfolio was rated number one (i.e., it was the most often viewed) on the site for several weeks in 1999.

Villa has plans to expand her own Web site but isn't rushing the process because Theispot-Showcase generates so much interest in her work. In fact, her plan for www.roxanavilla.com is to be more than a portfolio. "I'm interested in promoting myself as an artist, not just as an illustrator. My vision is that my Web site will be more than just a place to showcase my work. It will be a window to Roxana Villa."

Roxana Villa
Acrylic on Board
©1995 Roxana Villa

.....................................

For more information, check out Roxana Villa's bio or contact the illustrator.

Illustrator Roxana Villa has her own domain name (www.roxanavilla.com), but her official portfolio is posted on www.theispot-showcase.com.

Roxana Villa
email: rox @ roxanavilla.com

Click here to see Roxana's official portfolio. http://www.theispot.com/artist/villa
Check back here in the next month as this site develops.

Illustrator Roxana Villa's Web site (www.roxanavilla.com) is a simple one-page site that will eventually showcase her body of work as an artist, rather than just her illustrations.

Is the Physical Portfolio a Thing of the Past?

Don't trash your portfolio yet. Xenia Polchaninoff, art buyer at Lowe Lintas & Partners, speaks for many of your prospects when she says, "I don't have time to go searching online. It's easier to call in the books [or portfolios]."

In the meantime, you need to add a digital portfolio to your existing physical portfolio, because one is not a substitute for the other. In fact, they are used in many configurations: one instead of the other, one in addition to the other, one as a precursor to another. Some of the portfolio sites, such as Planetpoint (www.planet-point.com), even allow an art buyer to have the artist's portfolio delivered overnight (at no extra charge to either the artist or the client). "It's a timesaving device," says Planetpoint representative Dennis Gray, "and it eliminates the need for an art buyer to deal with artists personally. They just push a button, and they can order the reel or portfolio."

Illustrator Harry Campbell's marketing strategy is the opposite of Roxana Villa's: it's designed to drive prospects from three digital portfolios directly to his own Web site (www.hspot.com), where he displays more than a hundred examples of his work.

In addition to direct mail and his ongoing advertising in the print directories such as *The Workbook* and *The Alternative Pick*, Campbell has a digital portfolio on www.workbook.com and www.altpick.com (companion Web sites to those

two creative directories) www.theispot-showcase.com, all with links to www.hspot.com. And all of this online advertising cost him just about $1,000 in 1999. Saturation is the intent and the effect of these multiple online and offline marketing efforts. Prospects see his work all over, so his name and his style become more and more familiar, they are more likely to think of him when a need arises and he gets more work.

"My Web site is a place where people can get samples immediately. I can make it entertaining because it's my show, and there's no competition."

Harry Campbell, illustrator (www.hspot.com)

SAMPLES

LINKS TO MY WORK

Illustrator Harry Campbell has his work posted on three different portfolio sites, which all link to his own domain name (www.hspot.com), where he has over one hundred images posted.

Ask anyone about portfolio Web sites, and they will mention Theispot-Showcase. "It's a go-to place," says Dave Gray, president of XPLANE, an information graphics firm whose digital portfolio is found exclusively at www.theispot-showcase.com. "Art directors know of it and go there." Theispot-Showcase (originally theispot.com) has been around since 1996. It's a heavily trafficked site known in the industry as "The Illustration Internet Site" and is the recipient of two coveted Invision Awards for excellence in online design and interface.

Gerald Rapp—longtime illustrators' representative for artists such as Beth Adams, Natalie Ascencios, Jack Davis, John Pirman, Marc Rosenthal, James Steinberg and Michael Witte—partnered with Applied Graphics Technologies (a leader in the field of digital imaging) to launch the online-only illustration directory with thirty-five digital portfolios. Rapp made it easy and inexpensive for illustrators to participate, and he used his high-profile artists to attract others. And it's worked.

Theispot merged with the American Showcase Web site in 1999 to form a "super site" with 500 illustration portfolios and thousands of stock images. The combined site consistently logs two million hits a month. The site also draws traffic by offering art buyers additional reasons to visit, such as the stock illustration section and "Art Talk," the online discussion forum where artists, reps and art directors freely discuss issues such as contracts, art materials, industry trends and difficult clients.

[*resource*]

Theispot-Showcase

Phone: (888) 834–7768

E-mail: info@theispot.com.

www.theispot-showcase.com

the*i*spot·showcase™
the *illustration* internet site

We have great news! Theispot, the *fastest* growing illustration internet site, and American Showcase, the *leading* publisher of creative sourcebooks Inc., have joined forces on the internet to form a *super site*, Theispot-Showcase.™ Our site will soon include both illustration and photography, and provide you with the *best* web-based source for commercial imagery in the industry.

Browse through our portfolios to sample the *hottest* new work from hundreds of the *world's top artists*. Check the stock section to find quality selections immediately. The*i*spot-Showcase™ makes searching for the illustration talent you need *easier* and more *efficient* than ever.

Call us toll free with questions or suggestions at *(888) 834-7768* or e-mail us at info@the*i*spot.com.

american **showcase**

Looking for *more information* on American Showcase Inc.'s print publications and services? Check them out here: Showcase Illustration, Showcase Stock, KliK Showcase Photography and Labels to Go.

Theispot-Showcase (www.theispot-showcase.com) is known as the "go-to" place for illustration.

Artists' rep Jim Lilie knows that online marketing is mandatory, but he isn't ready to invest in a Web site for the five artists he represents. Still, he needs a place to send prospective clients who want to see the work right away.

That's why he has invested $1,000 per artist to post their portfolios for one year on the Web site of San Francisco-based Planetpoint, a site that calls itself "the resource for creative talent worldwide" and offers a broad range of talent—from graphic designers, illustrators and photographers to broadcast designers, creative directors and copywriters.

Lilie chose www.planetpoint.com, a relative newcomer to the portfolio site scene, because of the breadth and variety of talent featured there. Rather than focusing on a specific niche, like Theispot-Showcase has done with illustration, the idea behind www.planetpoint.com is to make the site a one-stop shopping mall for creative talent. "Art buyers come back to us no matter what they're looking for, because they think they can find it here," says Dennis Gray, representative of Planetpoint.

Selling Stock Online

Some say stock is killing the freelance assignment business in photography and illustration, but the reality is that selling stock online offers additional opportunities to both sell your work and be more visible. The people behind portfolio sites such as Theispot-Showcase and Planetpoint know this; they are making it a cinch for artists to sell their stock images while maintaining a separation between the two sides of the business, so that artists aren't competing with themselves.

Brent Lindstrom *Photography*

My approach to lighting is to give a three-dimensional quality to the image where product is "hero". To accomplish this, I paint with light using fiber optics.

REQUEST **PORTFOLIO**

Brent Lindstrom, a photographer who paints light with fiber optics, has his digital portfolio posted on Planetpoint (www.planetpoint.com).

The Creative Dept. Bob Mariani
Copywriter/Creative Director

ORDER **PORTFOLIO**

Bob Mariani - *Biography*
The Creative Department
173 Plain Street
Rehoboth, Massachusetts 02769

Bob Mariani is one of only a few copywriters who has his digital portfolio posted on Planetpoint (www.planetpoint.com).

Massachusetts-based creative director and copywriter Bob Mariani has also posted his portfolio on Planetpoint, and at the moment, he's the only one of his kind. Mariani first discovered Planetpoint through their ad in *Communication Arts* magazine. When he went to the site and noticed there were no writers listed, he called and found out that it was simply because no writers had expressed interest, so he signed on.

Mariani's portfolio includes thumbnail images of twelve ads he's written, which can be zoomed in on to read the actual copy. "Being the only copywriter on Planetpoint makes me stand out, though I'd like to think my work would stand out even if there were other writers' portfolios there." According to the monthly report that all artists get, www.planetpoint.com had "2,060 total hits for December 1999," and Mariani's pages had "127 visitors who spent an average of thirteen minutes each."

[*resource*]

DIGITAL PORTFOLIO SITES

- Theispot-Showcase (www.theispot-showcase.com)
- Planetpoint (www.planetpoint.com)
- Portfolio Central (www.portfoliocentral.com)
- Portfolios.com (www.portfolios.com)
- Graphic Artists Guild and Serbin Communications' Directory of Illustration (www.dirill.com)
- The Workbook (www.workbook.com)
- The Black Book (www.blackbook.com)
- The Alternative Pick (www.altpick.com)

CD-ROM Portfolio vs. Portfolio Site

While a CD-ROM is very effective for viewing large multimedia files quickly and creatively, designers and artists who have spent the time and money to create them have not found them to be effective marketing tools. Most disks never see the light of a CD drive. However, Maria Ragusa of The Alternative Pick (www.altpick.com) believes a CD-ROM is the best current solution for an interactive portfolio that has animation, audio, video clips and radio spots. Still, she believes that it will be phased out as people get faster connections and everything moves onto the Web.

chapter 5

er.5

how to do spam-free e-mail marketing

The mention of E-mail marketing tends to make people's faces transform into ugly grimaces associated with liver or Spam. And it's true that people seem to have a lower tolerance for unsolicited E-mail than for so-called "junk mail," or even telemarketing. But E-mail marketing isn't always spamming; it is simply the process of using E-mail to keep in touch with, and keep your name in front of, those with whom you have a relationship—past, current and possibly future customers; colleagues and vendors; even friends and family.

The most effective E-mail marketing involves sending messages to people who are already familiar with your work. In this chapter, we will look at the different ways creative professionals are using E-mail marketing to keep in touch with and stay connected to their markets.

[*definition*]

What Is Spam?

The true definition of spam is "E-mail that is not just unsolicited, but unwanted."

> *"Talk is cheap. Voice, or its lack, is how we tell what's worth reading and what's not. Voice is how we can tell the difference between people, committees and bots. An E-mail written by one person bears the tool marks of their thought processes. Authenticity, honesty and personal voice underlie much of what's successful on the Web."*
>
> **Adapted from *The Cluetrain Manifesto* (www.cluetrain.com)**

The Most Important E-mail Marketing Tool: Your Signature File

Your sig file, as it is commonly known, can identify not only who you are, what you do and where you are located; it can also make it supremely easy for prospects to get in touch with you in the way that's most comfortable for them. This is important because your prospects, in their moment of need for your services, need not only to remember you, but to be able to find your contact information and work samples without wasting too much time.

[*definition*]

> *What Is a Signature File?*
> A signature file is text that automatically attaches itself to the end of every E-mail message you send. It is used most often in business to convey contact information, as a letterhead or business card would.

A sig file is the simplest Internet marketing tool there is. It's also the most effective, because it is unobtrusive and well accepted by most everyone online. So make sure yours provides the information your clients need.

The Four Things Your Sig File Must Have

1. *Complete contact information.* Include all the possible ways you can be reached—office phone, cell phone, fax number, toll-free number, E-mail address, mailing address, domain name, even your office hours.

2. *Portfolio link.* Your prospect may want to see your work right away, so make it easy by including a link to your portfolio (either your own domain name or Web site or an online portfolio site posting your work). Make sure the URL takes your prospects directly to the page where your work is displayed rather than to the home page of a site where they'll have to search for your work.

3. *An image.* Attaching an image is sometimes better than offering a portfolio link, because your recipient needs only to scroll down or, at the very most, open an attachment. On the other hand, some people are wary of viruses that are trans-

mitted via attachments, so if you decide to include an image, offer a link as well so they can choose.

4. *Your tag line.* To stand out from the competition, every company needs a tag line or a seven-word blurb—a precise and concise description of the services offered—especially if your company name doesn't convey this information.

The tag line for David Curry Design is a concise description of the kind of design they produce and its specific advantage:

```
For good, clean design that really
    communicates
http://www.DavidCurryDesign.com
212 222 6630
```

The tag line for Kristin Harris Design provides information on the firm's specialty, including what they do and who they do it for:

```
Kristin Harris
Kristin Harris Design, Inc.
3035 Hazelton Street
Falls Church, VA 22044
703-536-9594 voice
703-241-7463 fax
We specialize in 2 & 3D Animation and
    Logo Design
Art and Animation for Kids
http://www.kristinharrisdesign.com
```

The tag line for XPLANE tells clearly what they value, as well as who they are and what services they provide:

```
XPLANE | The visual thinking compa-
ny, http://www.xplane.com/, is a small
group of artists, designers and visual
thinkers dedicated to turning complex-
ity into clear, effective, pictographic
communication.
```

Mount an E-mail Marketing Campaign

Creative professionals who send out regular promotional postcards and calendars swear by the results of keeping in touch with their target market over time. E-mail marketing is like translating direct mail onto the Internet, but it can be even more effective because it requires so little effort for clients to respond.

To be effective, you need to follow a few simple steps. First, compile a list of highly targeted prospects. These are either clients and prospects with whom you already have a relationship or people who sign up to receive your messages. Next, decide what to send. Quick tips are perfect for E-mail marketing, as are the answers to typical questions you get from clients, industry links and other resources, or a simple update on what's new in your business. You can even use E-mail to advise prospects and clients about your travel schedule and when you are available to take on new projects. The trick is to make your messages brief and useful. Don't ask them to spend too much time reading, or your message will take on the pall of spam.

Send Regular E-Mail Updates About Your Business

Believe it or not, your prospects and clients do want to hear from you, because they are likely to be in need of your services at some point. So the easiest E-mail campaign is one in which you periodically show examples of your latest projects. LECOURSDESIGN sends promotional E-mail messages, like the one listed below, every other month to show what they're working on.

> NEWS FROM LECOURSDESIGN
> Our firm was recently tasked with the design of an identity for a new venture named ZEROg Products. We developed the attached wordmark to communicate the progressive, scientific, and healthy nature of ZEROg. This is accomplished through custom typography and a superscript g connoting scientific notation. The g floats in zero gravity, hence ZEROg. Ice blue and metallic silver give it a technical yet light feeling.
>
> ZEROg Products produces "problem-solving products," a tag line developed by LECOURSDESIGN. Their first creation is an ergonomic backpack that evenly distributes the load to reduce fatigue.
>
> LECOURSDESIGN specializes in not necessarily corporate identity, brand identity, print collateral, and Web design. Call us and see how we can creatively enhance the perception of your organization.

"The above E-mail message went to the fifty people on the LECOURSDESIGN E-mail list, which includes friends and family, current and past clients and hopefully, future clients." In three short paragraphs, Lecours accomplished three important marketing tasks: He explained the thinking behind the project (as well as the result); he reinforced the identity of LECOURSDESIGN; and he called recipients to action, just in case they had a project coming up. Lecours also attached an animated picture file to the message showing a few logos the firm had recently done. Those who had the software to view the animation saw a minislide show; those who didn't saw a static image. The response to the message was very positive. Here is one reply from a prospect:

> Looks awesome, Dave—I actually like your radio tower logo a lot—that would be good to save for the future. Did you use GIF Builder? If so, you might slow down the animation a bit. It rolled through each logo in less than a second each. Great idea though—I love animated GIFs. I'm here for a couple weeks if you'd like to meet up for a lunch or happy hour sometime—we can talk some shop. Hope all's well, see you soon.

Not only did his prospect respond to the message, he also offered some valuable feedback and an invitation to meet. Working together on a project might be the next step.

David Lecours of LECOURSDESIGN sends E-mail messages about his recent projects and includes an image file with examples.

Send Monthly Tips to Your Own E-Mail List

Another way to use E-mail marketing is to send regular messages that educate your prospects and clients. That's one of the goals behind *The Levison Letter*, a monthly E-mail newsletter sent out by direct response copywriter Ivan Levison.

The Levison Letter started on paper in 1987, but in 1999 Levison made the switch to digital distribution; he now has 2,000 self-subscribed readers within the high-tech industry in thirty-seven countries. The messages are written in a very personable tone and cover copywriting topics for the Web. Levison isn't shy about using his E-mail newsletter as a marketing tool. Each issue begins with a request to forward the message to colleagues (which generates additional exposure) and ends with a pitch for his services and a call to action. Take a look at this excerpt:

```
THE LEVISON LETTER
Action Ideas for Better Direct Mail,
    E-mail, Web Sites & Advertising
Published by Ivan Levison, Direct
    Response Copywriting
January 2000
Volume: 15 Number: 1

Write it right in the Year 2000—Five
    resolutions for high-tech marketers

#1. Keep it simple.
    Your prospects don't want to think
about your message. They want to
understand, QUICKLY, exactly what your
product or service can do for them. So
don't use long sentences when short
ones will do. Don't use long words when
short ones will do. Explain benefits
clearly. Strip off the verbal fat and
write rock-hard, muscular prose that
gets results!
```

```
#2. Keep it short.
    Some years ago I used to write long
selling letters for clients. "The more
you tell, the more you sell" was my
watchword. And the long stuff pulled
just great. Now, things are changing.
Readers are less patient. Their atten-
tion spans are shorter. Which means
that the sales letters, E-mail, etc., I
write are getting shorter too. Does
this move to a shorter format bother
me? Absolutely not! The only thing any
direct response writer should care
about is what WORKS.
```

Beyond educating his readers (i.e., his prospects and clients), an E-mail newsletter achieves an important marketing goal for Levison: it shows what he knows and positions him as an expert in his field. Because it adds value to his services, he is convinced his E-mail newsletter tool is an essential element of a successful online marketing campaign.

[*resource*]

FREE ONLINE MAILING LIST SERVICES
 www.egroups.com
 http://topica.com
 http://listbot.com

"You never know when your prospects are going to want you. My E-mail newsletter allows me to stay in front of them twelve months a year."

Ivan Levison,
direct response copywriter
(www.levison.com)

How to Capture Names and Addresses for Your E-Mail List

Don't ever buy an E-mail marketing list offered to you by a stranger online. You need to encourage your prospects to sign up—to opt in, as they say—to receive your regular E-mail messages, so be sure to make the sign-up process easy. Offer a few different ways, such as a form to fill out on your Web site or through a list manager such as ListBot, where people can self-subscribe. Some list managers provide an E-mail address to which people send a message that says, "Subscribe me." Don't forget to offer it to people you speak with. Instead of simply asking for someone's E-mail address, say something like this: "I send out an E-mail newsletter about [your specialty], and I'd be happy to put you on the list." They will usually respond with their permission and their E-mail address.

XPLANE is "a small group of artists, designers and visual thinkers dedicated to turning complexity into clear, effective, pictographic communication." They provide information graphics to Internet companies with complicated business models and to publications such as *Business 2.0, Interactive Week* and *Time Digital.* XPLANE utilizes what's known as a "Weblog," a list of links with personal commentary. They took the idea to the next level when they began E-mailing their Weblog out every day to a list of approximately fifty subscribers.

Thus was born the xblog, their E-mail version of the Weblog. Here's how they describe it: "The xblog is a place to find (mostly) visual communication links: Web design, Web development, art, new media, information design, graphic design, logos, typography, photography, illustration, interface design, usability, technology, language, reference, search engine info, culture, etc." Below left is a sample of a typical xblog.

Xblog evolved from an internal resource into a marketing tool. At first it was just a way to share cool links with colleagues. Then Bill Keaggy, XPLANE's creative director, thought, "Why keep it private?" And they started sending it out to anyone who signed up on their Web site. This is not one of those quick and easy marketing tools, however. Keaggy spends an hour a day finding the links, and that doesn't include the time it takes to write his comments. But he's committed to xblog. "There are a lot of interesting things out there. If something is useful, I'll just pass it on," says Keaggy. "The xblog is not promotion of ourselves necessarily, but we're trying to increase awareness and skill in what we do: communicate complex ideas through easy-to-understand information graphics." Like other E-mail marketing campaigns, xblog certainly increases the awareness of XPLANE's name, which ultimately increases business and attracts more projects. It's clearly one of the things fueling the company's growth. In 1998 XPLANE consisted of two people; in 1999 they added twelve; and for 2000, they anticipate fourteen more positions filled.

```
xblog | the visual thinking weblog —> http://www.xplane.com/xblog/

Inquiry with Imagery: Historical Archive Retrieval with Digital
    Cameras
—> http://www.media.mit.edu/explain/
    papers/mm99/acm_mm99.html
    This is an awesome thought. "What can be explained when cameras
return historical images with your photographs? Everyday photo-
graphs tell where you have been and what you have seen. We are cre-
ating cameras and software that show you what was there before you
were."

The Book of the Future
—> http://www.futurebook.org/
    "The Future of the Book of the Future is an exploration and
visualization of the book by artists, writers, thinkers, historians,
and history makers. The subject is not whether books have a future,
but what new forms they will take. How will the future book contin-
ue to manifest creativity and disseminate knowledge? The Future of
the Book of the Future attempts to discuss whether generations to
come will continue to recognize the book as the interface of col-
lected thought and the catalyst for cultural change or regard it
after the turn of this century as a quaint, yellowing dinosaur."

MIT List of Radio Stations on the Internet
—> http://wmbr.mit.edu/stations/list.html
    "Links to over 9,000 radio stations. This is a list of radio
stations that have information published about them available on
the Internet. If a radio station is not on this list it is because
I am unaware that it has a Web page. If it has a Web page, please
let me know the URL and I will happily add it to the list."
```

"Our intention is to be a filter so people don't have to wade through a bunch of links and pages."

Bill Keaggy, XPLANE
(www.xplane.com)

Send E-Mail Press Releases to Press Contacts, Clients and Colleagues

Jeff Fisher, of Portland, Oregon-based Jeff Fisher LogoMotives, considers himself a shameless self-promoter. He estimates that three-quarters of his business comes through direct referrals from people with whom he keeps in touch—which he used to do by snail mail, but now he does online with his Web site, E-mail messages and E-mail press releases.

Twice a month, Fisher sends an E-mail press release announcing awards he has received, his work featured in various books and announcements of new clients, or the completion of a project. On the following page is a sample of Fisher's messages:

The Advantages of an E-Mail Marketing Campaign

1. **E-mail keeps you visible.** It keeps your customers connected to you and up-to-date on what you are doing. If you send something useful, like quick tips or an interesting industry-related link, they will also feel like they're getting something valuable from you.

2. **E-mail motivates people to respond.** If a prospect has been meaning to contact you but hasn't because she's been busy with everything else, your E-mail message will give her an opportunity to reach out; all she has to do is click on "reply."

3. **E-mail allows you to educate your market about your work, little by little,** which positions you as an expert and instills confidence in your ability to handle whatever projects a prospect may have.

SUBJECT LINE: TOOT TOOT!*
For Immediate Release
24 January 2000

JEFF FISHER LOGOMOTIVES FEATURED IN "BULLET-PROOF LOGOS" BOOK
The Portland graphic design firm Jeff Fisher LogoMotives is represented by 14 logo
designs in the new book Bullet-Proof Logos: Creating Great Designs Which Avoid Legal
Problems. The book, edited by David E. Carter—with an introduction by trademark
attorney James R. Higgins—focuses on design firms approaching identity projects in
ways that make their logos "bullet proof," or nearly immune from possible infringement
lawsuits. Published by HBI, an imprint of HarperCollins Publishers, the volume will
soon be available through bookstores and Internet book sources.

 The designs selected from Jeff Fisher's portfolio of logo concepts span his 20
years in the business. The logo for the Eugene University Music Association was
designed while he was in college at the University of Oregon. Seattle clients are rep-
resented in the publication by logos for the restaurant Glo's Broiler, the publication
The Reel Scoop and the Philandros singing group. The identity for Contract Attorneys,
a San Francisco firm, is included. The symbol for the Columbia River Gorge Visitors
Association, produced in conjunction with the U.S. Forest Service district office, is
also shown. Logos for eight Portland-area clients are considered "bullet-proof" exam-
ples. They include the identities for management consultant Diane Tutch, hairstylist
Jeff Maul, City Laundry, For the Birds, the UltimateBurrito restaurant, Carmen
Schleiger Architecture, the Ridgetop real estate development and avant-garde theater
company triangle productions! Most of the designs may be viewed on the Jeff Fisher
LogoMotives Web site at www.jfisherlogomotives.com.

 In the past five years Jeff Fisher has received over 135 regional, national and
international graphic design awards for logo and corporate identity efforts. His work
is featured in over 35 publications on the design of logos, business cards, brochures
and T-shirts. In 2000 Fisher was selected for inclusion in Who's Who in Art,
Architecture and Design, Who's Who in the West and Who's Who in the World. This past
fall he was named to the British volume Outstanding People of the 20th Century.

For additional information please contact:
Jeff Fisher
Jeff Fisher LogoMotives
PO Box 17155
Portland, OR 97217-0155
Phone: 503/283-8673 Fax: 503/283-8995
E-mail: jeff@jfisherlogomotives.com
Web Site: www.jfisherlogomotives.com

Hours: Monday–Thursday 8 a.m.–5 p.m.

* If I don't "toot!" my own horn, no one else will.

These E-mail press releases go to editors and writers of local business journals, such as the *Daily Journal of Commerce*, *Oregon Business* magazine and *Media, Inc.*, a Seattle trade publication for creative industries. Kris Brenneman, health care and media columnist at *The Business Journal of Portland*, has published some of Fisher's press releases. "It's a good way to find out what's going on," says Brenneman, "and we can process it quicker when it comes via E-mail."

Cesar Diaz, a writer for the "Business" section at *The Oregonian*, prefers to receive material via E-mail as well. "That way I can look at it on my own time and decide what to do with it." What he doesn't like is when companies send press releases both on paper and via E-mail. "I wish they would choose one or the other, but not both."

E-mail public relations, the way Fisher is practicing it, works. "Two major papers in the state did feature stories on my work in 1999. The story in *The Oregonian* resulted in twenty new clients immediately, and seven months later I am still get-ting calls." Incredible results, indeed, but that's not all. Print publicity can also translate directly into online publicity, completing the circle. A mention by Cesar Diaz of Jeff Fisher LogoMotives in the April 28, 1998 "Business" section of *The Oregonian* was included in the paper's online edition and is archived indefinitely on the publication's site.

But Fisher doesn't stop there. Getting the most out of his marketing effort, he also sends his press releases to his E-mail marketing list, currently 120 strong and made up of his clients and vendors, net-working pals (other designers) and friends, "because you just never know."

[*resource*]

FOR ONLINE DISTRIBUTION OF YOUR PRESS RELEASE,

CHECK OUT THESE RESOURCES:

> www.urlwire.com
>
> www.mediamap.com
>
> www.newsbureau.com
>
> www.prnewswire.com
>
> www.businesswire.com

"Each time I prepare a press release, I get pretty immediate results. Within a week or two, I get a potential client or job."

Jeff Fisher,
Jeff Fisher LogoMotives
(www.jfisherlogomotives.com)

Practice Cold (and Warm) E-Mail Marketing

If you target carefully, write concisely and approach people respectfully, you can use E-mail to begin a conversation with someone who may have never heard of you but whose need you can satisfy. How do you accomplish this? First, choose your prospect and find his E-mail address. Then send a brief message—no more than three sentences—telling where and how you got their E-mail address, who you are and what you offer (your tag line or seven-word blurb is perfect for this). Then ask him to reply if he'd like more information.

Peleg Top, of Top Design Studio, finds Web and E-mail addresses for his prospects in trade publications. "Cold E-mail marketing works better than cold calling on the phone," says Top. "It enables the prospect to respond without a confrontation." Top tells of sending an E-mail message to a prospect at a record company that he wanted to work with. "A day later she responded with a positive response, and we're now going through the introductory mode."

Each time writer and photojournalist Jed Block does E-mail marketing, he gets at least one job as a direct result. "And a job that I probably wouldn't have gotten otherwise," he adds. That's what hap-

pened when he sent a warm message to Mary Kramer of K&G Tax Consultants—warm, because Block is a client of the firm.

> Hey, Mary:
> I just updated my Web site and thought you'd be interested in an exercise that appears under "Current Piece of Work." If you haven't visited for a while, I invite you to look around the site. It's not all business—most of the time, I try to have a little fun.
> This is a onetime mailing that I thought might interest you. If you'd like to stay in touch, the site makes it easy for you. And please don't hesitate to contact me if I could ever help out.
> Thanks,
> Jed Block,
> who writes for businesses and people wanting to communicate clear, stimulating, professional information with others.
> http://www.jedblock.com

"What grabbed me was that all his message did was introduce his Web site," says Kramer. "It wasn't a big pressure thing. We had been thinking about doing a Web site for a year, so we were looking for help. When I got the message, I looked at his site, which was really creative. Plus, he was local." Since then, Block has worked on their brochures and a few small mailings, as well as their Web site.

If you have done your homework, if you have targeted carefully, and if you are truly offering something they can use, then you've initiated a conversation; and all it takes is one click to say, "Yes, tell me more." And if they don't respond, you've lost nothing but a few moments.

Send Only One Thought, Idea or Question per E-Mail Message

People often decide whether to keep or delete an E-mail message by reading the first few lines, what they see "above the fold," as that space is sometimes called. If you address another issue further down in the message or add a postscript at the bottom, it's likely they won't ever see it, because they may never scroll past the fold. So keep your message focused. Offer one idea, comment or question per message—two at the most. If you have more to say on other topics, send multiple messages, which makes it easy for people to file them in the appropriate folders.

While many people believe that all unsolicited E-mail is spam, those who use E-mail as a marketing tool can attest to its effectiveness. "People want me-mail, not junk mail," writes Seth Godin, author of *Permission Marketing*. So if you deliver marketing messages that Godin would consider "anticipated, personal and relevant," you can make contact with real prospects. E-mail keeps you visible, keeps your market connected to you and literally motivates people to respond. Most important, it is the succession of communication back and forth that builds relationships between you and the people who make up your market. If you do your E-mail marketing right, your recipients will actually look forward to receiving your messages. Instead of cursing you for sending something, they may actually thank you.

Six Easy Ways to Make the Most of E-Mail

1. **E-Mail Intro:** Quickly introduce yourself, and ask if they want to know more.
2. **E-Mail Follow-Up:** Check the status of a project, or remind prospects of their interest.
3. **E-Mail Networking:** Ask for or offer help, or do some business matchmaking.
4. **E-Mail Question:** Ask a quick question, and get a quick answer.
5. **E-Mail Feedback:** Solicit feedback on a specific subject.
6. **E-Mail Thank You:** Jeff Bezos, founder and CEO of Amazon.com, takes time every week to send simple E-mail messages of gratitude. "It's a classic example of something that's never the most urgent thing to do. But it's actually very important, in a soft way, over a long period." (quoted in *The Wall Street Journal*, February 4, 2000)

chapter 6

```
<html>

<head>
  <meta http-equiv="content-type"
  <meta name="generator">
  <title>Welcome to Guarino Woodm
  <csscriptdict>
   <script><!--
```

DesignSce
The Search Engine for

extend your online reach with strategic linking

It's the use of hyperlinks (often referred to simply as "links") that separates the Web from any other communication medium. Links allow you to get more information about some obscure topic just because you feel like it, to jump somewhere else on the Web—far away or just around the corner—with a single click. Links allow you to abandon the linear path of the real world and be led instead by the muse of cyberspace.

There are different kinds of links, some strategically placed, others happened upon serendipitously. There are links from general search engines, such as Yahoo! and AltaVista; from directories and portfolio sites, such as Planetpoint and Theispot-Showcase; and from industry sites, such as www.workbook.com and www.howdesign.com. Many people will find you through a link in the sig file in your E-mail messages and those you post in online discussion forums. In fact, if you think about it, links are what makes the Web a web and not just a huge library.

Linking stimulates "word of Web," which makes it one of the best ways to drive qualified prospects to your site. Most of your online prospects will arrive at your Web site by following a circuitous path—by linking to you, rather than typing your URL or Web address into the address bar on their browser.

In this chapter, we will see what's working for creatives who are getting work from both strategic and serendipitous linking.

[*definition*]

What Is a Link?

Links—also known as "hyperlinks" or "hotlinks"—are words, lines of text or graphics that, when clicked, load a new page into a browser. Links are the connections you make between you (or your Web site) and the rest of the Web.

Give Links on Your Web Site

Some creative firms prefer to maintain a closed site, with no links outward, because they want to keep visitors browsing (or captive) for as long as possible. "It's too easy to lose prospects if we let them leave our site," says the principal of a small design firm, expressing a common belief about online marketing. You may agree or simply be skeptical about the usefulness of links on your site. But Dan Janal, author of *Online Marketing Handbook* (www.janal.com), writes, "Links are a powerful marketing tool. You don't lose business because people leave your site; you gain business because people realize your property is located in the heart of all the things these customers want to see and do!"

Many creative professionals are driving traffic to their sites by giving links to other Web sites, even those of "the competition," thereby extending word of Web in their favor, and making theirs an open site, where visitors can come and go freely. An open site includes both reciprocal and one-way links to rich resources that might be useful to a visitor. Such resources might be Web sites that provide background information about some of the issues you deal with in your work, recommended articles and books on such subjects as branding and the role of design in business, and Web sites that offer downloadable software and clip art.

The "links" page on the Web site for LECOURSDESIGN, "Sites, Resources We Like," offers visitors categories such as design, illustrators, photographers, type, sports, interests and printers, plus the separate category "Clients We Like." A section of client links—listing the company names, short descriptions and URLs—can be a very effective marketing tool in itself. It is an easy way to thank your clients, promote their business ventures, build loyalty and cement your relationships with a little cyberglue.

The folks at New York City-based Guarino Woodman claim that most links pages are relatively boring, so they take the opposite tack in their "giving links" strategy. Their links are strictly humorous marketing and advertising-related sites, such as Advertising Humor; Truth in Advertising, a collection of vintage cigarette ads (http://www.chickenhead.com/truth/index.html) and The Ad Graveyard, a collection of real ads that almost ran (www.zeldman.com/ad.html). "We're not trying to make a statement about being the authority on advertising," says Michael Guarino. "Instead, it's 'Let us brighten your day.'"

Three Great Things Strategic Links Can Do for Your Business

Strategic links can do wonders for your business. Multiple linking relationships provide a network of "good connections" that make it easier for you to extend your reach to new prospects, expand your market and grow your business. Links can (and do)

1. **Increase traffic.** By exchanging links with reputable industry sites, you create more opportunities to be seen online. Links also allow you to build bonds with sites that may have more exposure and stronger connections than yours to the markets you're after.
2. **Boost your credibility.** Links from the Web sites of respected colleagues are the equivalent of online endorsements, which is essential in a place as anarchic, unstructured and vast as the Internet.
3. **Add value to your Web site.** By offering to your visitors links to resources, your Web site will be perceived as a valuable one, and people will bookmark it and return in the future.

IDENTITY | BRANDING | ADVERTISING | BROCHURE | TRADEMARK | LECOURS

SITES, RESOURCES WE LIKE

design - Communication Arts, HOW, Publish, Print, Graphis, Critique
illustrators - J.Otto Siebold, Hersey, Jan Collier, Optic Nerve, Lance Lekander
photographers - The Alternative Pick, Rick Chou, Viewfinders, Dana Maione
type - Emigre, T26, House Industries, Thirst, FontShop, Garage Fonts, TypeRight
resources - Adobe, Photodisc, Amazon.com, AIGA, MetaCreations, Corbis Digital Stock
sports - NBA, RSN, Surflink, Mountainzone, Isuzu, Mammoth, Instantsports, Surfrider Foundation, Charged
interests - Volvo, LA Times, Catalog Site, MSNBC, Costa Rica, Oakley, Nike, K2, Burton, Patagonia, Tommy Trojan
printers, pre-press - Foundation Press, AdageGraphics, Automated Binding & Mailing, Lithographix

WE LIKE CLIENTS

Kirkpatrick Associates, Architects
Production Photo/Graphics
University of Southern California
Stephen Woolley and Associates, Architects
Bank of America
Hughes
Chubb

the firm | staff bios | e-mail us | our store

3713 HIGHLAND AVENUE 4A, MANHATTAN BEACH, CA 90266
TEL 310.546.2206 FAX 310.546.2826 david@lecoursdesign.com

The "links" page on the LECOURSDESIGN Web site
(www.lecoursdesign.com) offers online resources, as well as
links to the Web sites of their clients.

GUARINO WOODMAN

portfolio
contact us
site map
about us
Links
recent work

Your average links page is relatively boring......

At Guarino Woodman, we don't do
anything average.

The Ad Critic -

Advertising Humor

The Institute of Official Cheer -
Including the Gallery of Regrettable
Food, Bad Publicity and more -
including "regrettable food ads!"

Joke of the Day

Truth in Advertising - A collection of
vintage cigarette ads from the age of
innocence.

The Ad Graveyard

Today's Cartoon

[portfolio] [contact gw] [site map] [about us] [links] [recent work]

The "links" page on the Guarino Woodman Web site
(www.guarinowoodman.com) is all advertising humor.

Get Links From Other Web Sites

"It's all about exposure. The more your name is out there, the more familiar people will be with the services that you offer."

Steve Grandis,
Curran & Connors, Inc.
(www.curran-connors.com)

The links on your Web site are only half the picture. "Ideally you should be linked from every high-traffic site that is of interest to your target market," writes Susan Sweeney in her book, *101 Ways to Promote Your Web Site*. The goal of your linking strategy then, is to link yourself and your Web site to and from the Web sites where your prospects are looking for information. That way, you benefit from the exposure and the online marketing of these sites. For example, the Web sites of popular business publications are becoming more than just information purveyors; they are also becoming useful resources. Both *The Industry Standard*, a magazine for "the Internet Economy" (www.thestandard.com), and *Inc.* magazine (www.inc.com) offer online business-to-business directories that include creative professionals.

Web sites abound that are hungry for visual content where you can submit your work for online publication: online galleries of software companies, such as Adobe and COREL; stock image companies, such as EyeWire; and online publications, such as *Electronic Publishing*. This could easily translate into some free online publicity and linking.

[*resource*]

ONLINE GALLERIES WHERE YOU CAN SUBMIT YOUR WORK
- www.electronic-publishing.com
- www.macromedia.com/gallery
- www.adobe.com
- www.corel.com
- www.eyewire.com

Link Locally

- **Is there a business-to-business online directory on the Web site of your town or city?**
- **Can you exchange links with other area businesses?**
- **Does your association or professional organization offer links to members' Web sites?**

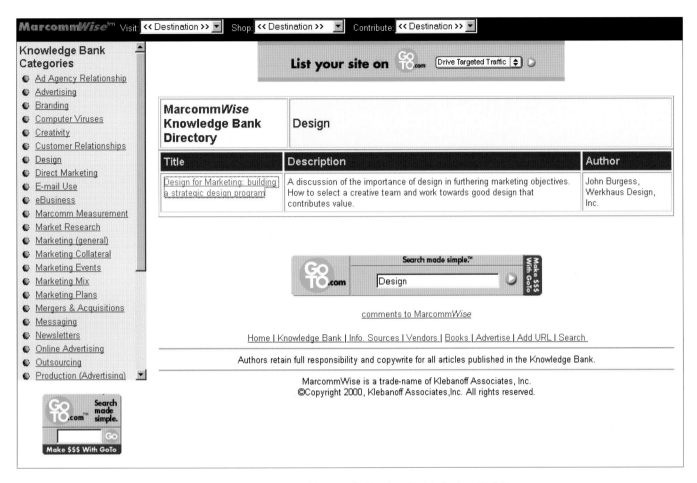

Make Yourself the Expert

The Web has made publishing a cinch, and there are many opportunities for designers with a literal bent to get articles published online. These are not self-promotion articles, mind you, but informational articles that position you as an expert in design, branding, copywriting or whatever your specialty is.

MarcommWise (www.marcommwise.com) is one of these sites. Besides being an online directory of marketing and communications professionals (where listings are free, so get yourself listed), the site includes a "Knowledge Bank" of informational, how-to marketing articles. "Rather than simply listing in our 'Vendor Directory,'" says Joel Klebanoff, who runs MarcommWise, "getting linked through an article offers the author a chance to prove his or her expertise in marketing communications."

John Burgess of Werkhaus Design in Seattle

posted his article "Design for Marketing: Building a Strategic Design Program" on MarcommWise with a link to his firm's site, then used it as an opportunity to do a little E-mail marketing to his clients. He sent out a message with a link to the article, raising his profile a notch in the eyes of those who are already familiar with his work.

If your expectations for this kind of exposure are realistic—that it is part of a campaign to increase your overall visibility and credibility rather than generate hot leads—you'll be pleasantly surprised by the connections you can make.

[*resource*]

WEB SITES HUNGRY FOR ARTICLES

- www.marcommwise.com
- www.visualartstrends.com

An article written by John Burgess of Werkhaus Design is posted in the "Knowledge Bank" on MarcommWise at http://www.marcommwise.com.

Exchange Links With Your Colleagues and Your Competition

"Bartering links (or reciprocal linking) is a definite traffic builder for any smart marketer's Web presence," says Mary Gillen, codeveloper of Idea Site for Business (www.ideasiteforbusiness.com). That's the strategy at the heart of Monster, a group of San Francisco-based illustrators who live by the controversial "collaborate-with-the-competition" philosophy. Not only do the Web sites of most of the artists include links pages featuring the sites of all of their colleagues, the group itself has a Web page that is, in essence, nothing more than a links page.

The basic tenet of the group, which includes artists such as Susan Gross, Bud Peen, Michael Wertz, Marcos Sorensen, Pamela Hobbs and Brian Biggs, is that they are not really in competition, because their styles are so different. "We have a tight-knit community of friends and artists here, and we'd rather be supportive than competitive," says Michael Wertz, the administrator for the group.

Wertz is also a member of the Graphic Artists Guild Illustrators Web Ring, another cooperative linking situation. "It's like a Web club," says Wertz. "People stumble across one of the sites, then when they click on the icon, they are taken to the next site in the ring." And it works. He's says he gets a couple hits a day from it. To be included, you must be a member of the Graphic Artists Guild and have a portfolio link on the organization's site. Find out more about Web rings at www.webring.org.

How to Ask for a Link

Placing a link on a page is a cinch; all you need is a simple line of computer code. The challenge of linking is the personal aspect. If you want someone to link from their site to yours, it's not usually enough to say, "Link to my site." Even asking nicely doesn't always work. You must give them a reason to link, and the best reason to offer is that a link to your site would add value to theirs—which is why it's a good idea to have a links page of your own or offer links throughout your site.

Sometimes offering a link to someone on your page motivates them to reciprocate. But don't link just for the sake of linking. Crowding your pages with unhelpful links or long lists of links will dilute your own message and become too unwieldy for visitors to wade through.

Everyone benefits from being in a network of businesses cooperatively linked to each other. Linking related Web sites opens new doors for everyone, because the more you appear on other sites via links, the more exposure you gain. And the more links to you, the more potential clients will visit your site.

Make your linking strategy part of your online marketing plan (see chapter 9). Do a little each day, finding and bookmarking appropriate Web sites, then sending your personalized (yet generic) introductory message to them. Soon enough, people will be seeing your name all over the Web.

The illustrators who are members of Monster (clockwise from upper left): Susan Gross, Adam McCauley, Isabel Samaras, Marcos Sorensen, Lloyd Dangle, Michael Wertz, Dave Gordon, Gordon Studer, Brian Biggs, Bud Peen and Pamela Hobbs.

Hello! And welcome to the Monster Illustration Hut. Monster is a group of Illustrators who get together for periodic mailings, in the process saving a tree or two. (And it's fun, too.)
* **Take a sneak peek at our <u>new mailer</u>!**
* **Get on our <u>mailing list</u>.**
* **See our <u>team photo</u>!**
Click below to see our individual pages. Thanks for stopping by.

brian biggs

bud peen

lloyd dangle

isabel samaras

dave gordon

marcos sorensen

susan gross

gordon studer

pamela hobbs

michael wertz

The Web site for Monster, a collective of San Francisco-based illustrators, is a page with links to each member (www.monsterillo.com).

Strategic Registering

As recently as 1998, searching the Internet for graphic designers was a relatively painless process. "There just weren't that many designers with Web sites," says Kevin Owens of Playworld Systems, a manufacturer of children's playgrounds, who was looking for a designer at that time. "The entire process was one evening's work viewing several designers' Web sites. I narrowed the selection to four, whom we visited and interviewed, and ended up working with two of them."

Not so anymore. These days, any client who types the words graphic design or corporate identity into her favorite search engine knows she is likely to be overwhelmed with an unmanageable list of possibilities. The problem is obvious: There's so much information on the Web now, many people feel lost before looking very far; and some know before logging on that they're likely to come up empty-handed and frustrated.

According to Eric Ward, writing in *Advertising Age*'s Business Marketing Web site, "Most search engines are becoming more and more useless to the typical enduser. As [they] get frustrated, they begin to look for what they need in other places, like topic-specific search engines and directories." That's why your marketing energy and efforts should be directed not only toward getting and giving links, but getting listed (or "strategic registering") in design industry Web site databases, such as the Graphic Artists Guild (www.gag.org), as well as niche-targeted databases, such as Workbook.com and Creativepro.com.

The Web site for Wee Small Hours Design, a New York City-based design firm (www.weesmallhours.com).

Get Listed in Specialized Industry Databases

Ellen Hibschweiler's online marketing strategy for Wee Small Hours Design, her Manhattan-based firm, is focused on getting its Web site listed on design-oriented search engines. Hibschweiler is especially interested in search engines and directories that have relatively short lists of designers, because she knows that if prospects can search without being overwhelmed by the results, the chances that Wee Small Hours Design will be seriously considered are much greater.

Wee Small Hours Design is one of a couple dozen design firms listed on the Web site of the Graphic Artists Guild (www.gag.org), where, for $25 a year, members of the organization get a one-line description of their services and a link to a Web site.

Through this link Shantal Persaud from the World Bank, a large governmental agency in Washington, DC, first found Wee Small Hours Design. "We were looking for a really good designer who would be creative and innovative. Location was not a problem," says Persaud. "A colleague suggested I start my search at the Graphic Artists Guild site. Wee Small Hours immediately caught my eye because the layout of their site was very energetic and I liked their approach to clients."

DesignScout.com, a searchable database of design firms, generated yet another big client for Wee Small Hours Design. Within two months of being listed, Hibschweiler was contacted by Beth Friedmann of Doar Communications, a Long Island, New York-based provider of litigation technology. Friedmann had her end result in mind—new product brochures—when she began her search for a design firm. She wanted to work with someone local but didn't know where to begin looking, so a colleague recommended she visit DesignScout.com. "I went there to search for freelancers in New York whose profiles fit my qualifications," says Friedmann. "I found a few, looked at their online portfolios, then sent a bunch of E-mails to those whose work I liked."

Since that initial successful project, a relationship has developed and Wee Small Hours Design has done five projects for Doar. Although getting listed on these specialized search engines has been a positive (and lucrative) experience, Hibschweiler considers these projects icing on the cake. "I've seen two direct clients through these two links, but even if I don't see anything, the long-term name recognition is worth it."

"My largest client found me through the Graphic Artists Guild Web site. They never would have found a company my size otherwise."

**Ellen Hibschweiler,
Wee Small Hours Design
(www.weesmallhours.com)**

A link to the Wee Small Hours Design Web site in the Graphic Artists Guild "Portfolios" section.

The profile of Wee Small Hours Design on DesignScout (www.designscout.com).

DesignScout.com is a searchable online directory for the design industry. Design firms pay a fee to be listed, while buyers of design services access the database at no charge to search by criteria such as category, experience, location, industry specialization, discipline and past clientele.

For an annual fee (which ranges from $300 for small firms to $2,000 for larger firms), member firms get a complete profile with a link to their Web site and monthly reports detailing which companies have accessed their profiles. In addition, the DesignScout E-mail newsletter, sent monthly to users of the site, features "Members' News" and "Design Firm of the Week," giving additional exposure to this target market.

Named one of the top 10 Web sites by *HOW* magazine in August 1999, DesignScout.com's database of members includes top firms such as Landor, Fitch, FutureBrand, Enterprise IG, Sterling Group, Wallace Church, Desgrippes Gobe, Interbrand and SBG.

Unlike some of the free listing sites, DesignScout.com is aggressively marketed to attract medium and large companies (typically over $100 million in sales) to visit the site and use the database. It has been featured in online and offline publications such as *VM+SD, Graphic*

Design USA, Business Marketing, ICONOCAST, Brandweek and Ad Age's Creativity. As a result, design firms such as Wee Small Hours Design have made lucrative connections.

The DesignScout Web site (www.designscout.com) is a searchable database of design firms.

[*resource*]

DesignScout.com
www.designscout.com
(212) 752–3386
(888) 404–7766

What About the Industry Web Sites of Your Prospects?

In addition to getting listed on design-oriented Web sites, the trade groups of your prospects and clients may have an online directory where you could be listed. (This may require that you join as an affiliate or associate member, but you should anyway, because becoming active in their trade organization is a great way to actually meet your prospects.)

The Web site for National Investor Relations Institute (NIRI; www.niri.org), a trade association with 4,200 international members in the financial community who are responsible for investor communications, has a "Resource Guide" section, which includes listings and links to all the services a director of investor relations might need, including annual report designers, photographers, printers and more.

NIRI member Steve Grandis of Curran & Connors, whose firm has gotten clients as a result of their listing on the NIRI Web site, says, "It's all about exposure. The more your name is out there, the more familiar people will be with your services that you offer."

[*resource*]

National Investor Relations Institute
www.niri.org
(703) 506–3570

Practice Targeted Registering With Online Business Directories

"Although registering with major search engines is a free marketing tool," says Marius Ursache, creative director of Grapefruit Design, a creative agency based in Romania, "it's far from being one of the important tools in my company's marketing strategy." Instead, Ursache employs a strategy he calls "targeted registering." "We register in business directories and on Web sites where clients would search for a company like ours."

Ursache's favorite site is www.about.com. Also known as a vertical portal, About.com is a Web of more than 700 topic-specific sites, each of which offers an abundance of information. Each section of About.com is maintained by a featured expert on the particular topic. The graphic design section, (www.graphicdesign.about.com) is maintained by Judy Litt, who posts pertinent information, moderates the graphic design forum and is available to answer questions.

For the design and creative industries, many of these subject-specific or specialized online directories are popping up, and offering creative firms various opportunities for exposure, from basic listings and portfolio space in general directories to in-depth profiles in searchable design and communication industry-oriented databases aimed at end users. You don't necessarily need a Web site to get listed.

For example, in the free listings category, www.uscreative.com and www.creativepro.com are specialized directories for creative services, including design, illustration and copywriting, among others. On the other end of the free listings spectrum, job sites, such as www.aquent.com (Aquent is also the official talent agency of the AIGA) is a more general database of people offering their full- and part-time creative services. And www.workbook.com has a comprehensive and searchable online directory (companion to the printed version) containing 50,000 national listings of almost everyone in the creative industries, so make sure you're listed there.

[*resource*]

FREE INDUSTRY DATABASES WHERE YOU CAN GET LISTED

www.adforum.com

www.artdirection.com

www.creativepro.com

www.designshops.com

www.dsphere.net/b2b/directory.html

www.findcreative.com

www.graphicdesign.about.com

www.graphicdesigners.com

www.uscreative.com

[*resource*]

GENERAL ONLINE DIRECTORIES WHERE YOU CAN GET LISTED

www.aquent.com

www.netb2b.com

www.freeagent.com

www.guru.com

www.monster.com

www.smarerwork.com

www.ework.com

www.icplanet.com

www.soloskills.com

www.ants.com

"Targeted registering is more rewarding than trying to be in the top of a search engine listing."

**Marius Ursache,
Grapefruit Design
(www.grapefruitdesign.com)**

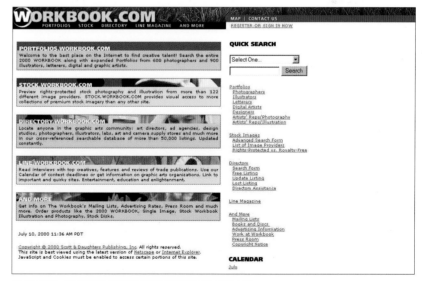

On the Web site for The Workbook (www.workbook.com), you can access their "National Directory of Creative Talent."

Get Listed in the Major Search Engines

Expecting to be found by high-quality prospects through the major search engines is a little like expecting to reach buyers of creative services by placing a classified print ad in *The New York Times.* You may reach a wide audience, but most of them will have no need for your services. A search for "graphic design" on Yahoo! yields 6,394 listings, a manageable number compared to the more than 547,000 from AltaVista and Google's approximately 188,000. Still, most of the sites that come up are resources for graphic designers, not the Web sites of actual designers. The first ten listings for "illustrators" on yet another search engine brings up trade groups for illustrators, as well as the illustration portfolio site Theispot-Showcase, but no Web sites of illustrators are found in the first thirty listings. On a different search engine, a search for "annual reports" brings up 111,000 links, the first twenty of which were actual annual reports for corporations, as well as a site that links to all the corporations who distribute their annual reports online. Yet, no design firms that actually design annual reports are in the forefront of that list.

In this section, we'll look at how the search engines work and what some creative firms are doing to make their Web sites search engine friendly. But keep in mind that search engines are mass marketing vehicles and, although they can generate projects both big and small, only one source—and probably not the best source—for new prospects to find creative professionals.

How to Make Your Web Site Search-Engine Friendly

Not all search engines are alike, and the difference boils down to the various ways that they acquire, store, categorize and search through data. Some send spiders and crawlers and robots out to scour the Web, then take the data back to index it. Others wait for you to submit your site to them. And still others do a little bit of both. For example, AltaVista and Lycos send their spiders out to find Web sites, so even if you haven't submitted your site, you may eventually be indexed there. In fact, if you have a Web site, you may already be.

Yahoo!, on the other hand, is not exactly a search engine but a directory, and it does not have

People Type What They're Looking For

The first thing many time-pressed searchers do is type what they're looking for in the form of a URL to see what Web site comes up. With this in mind, Guarino Woodman, a New York City-based ad agency, has secured the domain names www.nycadagency.com and www.nycadvertising.com so that when someone types that in, they will get a page that links to the official Guarino Woodman Web site, www.guarinowoodman.com.

crawling spiders. Instead, Yahoo! relies on submissions from site creators and employs real people to compile their listings into subject-based, hierarchical categories. So if you don't submit to Yahoo!, it's not likely you'll be listed. In fact, even if you do submit to Yahoo!, it's not easy to get listed; it takes a long time and sometimes many tries, but because Yahoo! remains one of the most popular directories on the Web, it's worth it.

In the early years of the Internet, search engines placed heavy emphasis on the hidden list of keywords called "meta tags" that can be embedded in the HTML code on your pages. But today, search engines attempt to simulate the way human beings read a page. In addition to meta tags, crawlers can pick up the first twenty-five words of visible text on a Web page for indexing. This can be a problem for designers' and illustrators' Web sites, which often rely more on graphics than on text. Your Web site design, then, may be inhibiting the search engines from finding you. (See the search engine tips sidebar below for ideas about how to fix that.)

Three Tips to Help Search Engines Find Your Web Site

Guarino Woodman gets a lot of inquiries through the search engines, and according to illustrator and Web designer Heather Chernik, who designed and created their site, you must have a balance of your keywords in all meta tags indexed by the search engines. Use a few of Chernik's tips on keywords:

1. Write the tags so that the most important words appear first.
2. Don't repeat your keywords over and over in your meta tags. This is a trick used by many who believe it will bring their site higher in the ranking. But instead, search engines often push those sites to the end of the list.
3. Use grammatical and spelling variations on your keywords, such as graphic design, graphics, graphic designers, graphic illustrators, graphic artists, graphic design solutions, graphic design information and graphic design resources.

The Web site for Guarino Woodman (www.guarinowoodman.com).

The process.

We all know that the best results can only be achieved by taking the right steps to reach a final goal.

Advertising is the perfect example of this. At Guarino Woodman we never take a shortcut, recycle old ideas or try to create advertising for the sole purpose of winning industry awards (although we've won many). It's about results.

Before we attempt to solve any marketing problem, our team takes the time to first listen to our clients needs, an important step that a lot of agencies have forgotten to do. Then we do extensive research and start to develop ideas that work. Once everyone agrees it's the way to go, our production department will make sure that every detail of the process from photography to printing is handled in the most professional and cost effective way.

As you can see by our site we are always evolving and updating our ideas. Our prime goal is to deliver a product that is fresh, well thought out and effective. Take a few moments to look at Guarino Woodman, it's a process well worth taking.

Make the Most of Meta Tags

Like peering directly into a company's boardroom and lifting the curtain on their marketing plan, you can view the meta tags of every Web site you visit. Simply choose the "View" menu from the tool bar, then click on "Source," and a window will open with HTML text that you can study. Of all the HTML code and meta tags you see, the title, description and keywords are the most important, but your keywords should be used in as many places as possible, including on your pages. Here are the meta tags for www.guarinowoodman.com:

Title

The page title is important because that's what your visitor sees at the top of their browser window when they visit your site. Make sure each page has a title that makes sense to visitors, not just to you. Crawlers also sometimes pick up the title of a page, so be descriptive. Failure to put strategic keywords in the page title is one reason why Web pages can be poorly ranked.

Description

When your Web site comes up in search engine findings, it is the description text that is displayed, which means it's your opening statement that people will use to decide whether or not to click on the link. Make it descriptive. Guarino Woodman's description reads: "advertising agency in new york city specializing in cable television, sports, entertainment, fashion, financial, corporate identity including print, collateral, television, web, radio, and media placement."

Keywords

Keywords are used for many things, including indexing your site in the databases of major search engines. Put your keywords in all of your meta tags, as well as in the first twenty-five words on your home page. Guarino Woodman's keywords include: advertising, New York, art, NYC, ads, graphic design, advision, sales promotion, direct mail, web, TV, design, radio, internet designs, logos, corporate identity, id, ad, agency, art director, client, creative direct, copywriting, media, marketing, video, sales.

The meta tags for Guarino Woodman's Web site generate a lot of inquiries through the major search engines.

Keywords Are Key

Your keywords are not just what the spiders go looking for when they scour the Web. You are often asked for your keywords when you list your site with a directory and when you post your work on a portfolio site. You may need them at a moment's notice, and if you don't have them ready, you may miss an opportunity to get listed somewhere. So have them handy—in a separate, easy-to-access document—and ready to use.

What Are Your Keywords?

Which words will your prospects and clients type into the search field when they are looking for a designer, an illustrator, a copywriter? Your challenge is to think literally about your work and to describe it in the words that your prospects will use. Use these simple techniques to find your keywords:

1. Listen for the phrases your clients use most often to describe what you do for them. Do they think about your services by subject, style, medium, the service they're looking for (graphic design, illustration, copywriting), the end product they will get (annual reports, collateral, Web design) or something else?
2. Make a list of ten possible keywords for your firm and do a Web search to see what comes up.
3. Survey your clients and prospects. Tell them what you're doing and ask for their input. Most people will be happy to contribute to a process that can make their own work easier.

Search Engine Submission Services

Search engines find things fast, but they sometimes take forever to index your pages. There are many services that will submit your Web site to the search engines—some free, some for a fee. Some claim to cover all the "major" search engines, others boast that they'll register you at 450 or more search engines. It's one of those things where it doesn't hurt if the price is right (i.e., zero), but results are not guaranteed and accuracy is dubious. "For the best results, register individually and manually with as many of the top search engines as you can before resorting to multiple submission sites," writes Susan Sweeney in her excellent book, *101 Ways to Promote Your Web Site*.

[*resource*]

SEARCH ENGINE SUBMISSION SERVICES
- www.submitit.com
- www.123add-it.com
- www.selfpromotion.com
- www.websitegarage.com

Use Your Time Wisely

Maintaining a high ranking on search engines is an arduous task that takes full-time, practically religious devotion. Plus, more often than not, these efforts don't even work, particularly if you're competing in a niche with well-established and better-financed competitors. According to Danny Sullivan of SearchEngineWatch.com, most users will not bother to look past the first screen—or top ten (or twenty or thirty) listings—of a search. Being listed eleventh or beyond means that many people may miss your Web site. It is not possible to get yourself into the top ten unless you invest a lot of time on an ongoing basis, which he doesn't recommend. "Don't waste your time creating special pages and changing your sites to get better placement," writes Sullivan. "This time could usually be put to better use pursuing non-search-engine publicity methods."

By all means, register with the major search engines and free directories. Say yes every time you land on a site that offers a free listing, because you never know who's going to be looking where and for what, especially as people become more accustomed to searching for services online. Have your seven-word-blurb ready to copy and paste, have your ten keywords ready and devote a certain amount of time each week or each month to your listings in databases and directories.

The bottom line is that while meta tags—and therefore search engines—are important, if you want more control over who finds your Web site and if you want to drive the right kind of prospects instead of any old surfer to your site, then focus on strategic linking and targeted listing.

[*resource*]

Danny Sullivan
search engine expert, whose site offers a wealth of up-to-date information about search engines and how they work, including a listing of the top ones to focus on.
www.searchenginewatch.com

*section.*three

beyond marketing

chapt

chapter 7

online market research

There's a wealth of information on the Internet just waiting to be harnessed, so you'd think that would make researching your market easier, but in fact it doesn't. You can gather information about potential clients and identify new target markets by doing market research online, but you have to know where to look and what to look for; otherwise you can quickly get overwhelmed and frustrated. In this chapter, we'll look at what business-related information is available on the Internet and how creatives can find and use it in the online promotion of their services.

"Digging for prospects is very exhausting work. The Web is HUGE."

**Marius Ursache,
Grapefruit Design
(www.grapefruitdesign.com)**

In centuries past, researching your prospects, like almost everything else, was much more time consuming and labor intensive. If you wanted to find out about a company you were interested in working with, you had to go to the library, make phone calls, pry details out of surly receptionists, sometimes even pretend to be someone you weren't in order to get the information you needed.

Now, you can type a name into a business directory, such as Hoover's (www.hooversonline.com), or a search engine and go right to the company's Web site. There you'll often find a wealth of information, including an overview of the company, what they do, what products and services they offer, what they value—everything you need to be able to speak from an informed perspective. A little time spent on a prospect's Web site will tell you more than you would be able to find out on the phone. And the more you understand about your prospects, the more likely you are to engage them in a conversation, which is the first step toward a working relationship. Beware, though, of unofficial Web sites. If you're not sure if the one you've landed on is the real thing, call the company and confirm the URL.

Visiting a prospect's Web site helps illustrator Bud Peen draw up an estimate for a project. He can get a sense of the quality of work they expect, which helps him set his fees, and decide whether the job is up his alley.

Once you see what a company says about itself, you can find out what others are saying. Following an initial inquiry, you can do a search to see what information is out there, including Web pages, directory listings and articles about a company. This information gives you a fuller picture so that, from the very first contact, you are more informed. When you take the time to do your homework, you present yourself as a professional, which your prospects often appreciate.

Terry Edeker, of Alabama-based Edeker & Edeker Design, uses online research tools for new business efforts. "It is important when approaching a potential client that some research has gone into understanding their needs within their industry. This also demonstrates that we have spent a considerable amount of time understanding the problems they face and have some initial thoughts as to how we can assist in meeting those needs."

What You Can Learn From a Company's Web Site

- **Products and services:** These give you the details you need to tailor your portfolio and work samples to emphasize your experience and familiarity within its industry.
- **Its customers:** By finding out what kinds of problems the company solves for its customers, you can communicate how you can address those needs.
- **Corporate style:** A site's content, both text and graphics, tells you the company's "style" and helps you present yourself in the best light. Are its people buttoned up or buttoned down, creative or technical, on or off the cutting edge, playful or ultraprofessional?
- **Contacts:** Many Web sites list the company's key players, making it easy to decide who is best to approach or whether there is more than one good contact.

Thanks to the Web, you can rent and download traditional mailings lists, pour them into your mailing list software and have it spit out labels for a mass mailing, most of which is not so new. But mass mailings are a thing of the twentieth century. One-on-one is the marketing buzzword for the twenty-first century, and the Internet offers much valuable information for those willing to spend the time compiling their own list.

There are also many lists available online—membership lists for local chambers of commerce and trade associations. For example, in February 2000, *The Wall Street Journal* published an article stating that more lawyers are using professional graphics in the courtroom. Well, there's an opportunity, so you decide to explore this market. The first thing you need is a list of law firms; in fact, a list of trial lawyers would be even better. So you start searching for associations of trial lawyers to see what information is available. The Association of Trial Lawyers of America (www.atlanet.org) is a good place to start.

This association has links to the Web sites of more than forty local chapters, and, as a benefit to their members, many of these chapters post their member directory on their Web site. You can begin compiling your list by selecting from those listings. You may find a list with phone numbers, but no addresses, or a list with links to Web sites, but no phone numbers. So decide how to approach these new prospects—by direct mail, by E-mail, by

phone—then get the information you need. And just to be safe, check the Web site for guidelines on the appropriate usage of this proprietary information.

By the way, using contact management software, such as Symantec ACT! or FileMaker Pro, to manage this list will keep your marketing extremely well organized, which is crucial to any effective marketing plan.

[*resource*]

MARKET RESEARCH WEB SITES

Dun & Bradstreet (www.dnb.com)

Web CMO (www.webcmo.com)

Thomas Register of American Manufacturers (www.thomasregister.com)

Hoover's Online (www.hooversonline.com)

Chamber of Commerce International Directory (www.chamber-of-commerce.com)

[*resource*]

MAILING LIST SOURCES AND BROKERS

The Workbook (www.workbook.com)

Adbase Creatives (www.adbasecreatives.com)

The List (www.thelistinc.com)

Creative Access (www.creativeaccess.com)

American List Counsel (www.amlist.com)

Edith Roman Associates (www.edithroman.com)

infoUSA (www.infoUSA.com)

Wouldn't it be great to have a marketing team whose sole responsibility was to find the decision makers that hire creative professionals and hand their contact information to you on a silver platter? Well, that's pretty much what you get with The List®. It's not a traditional mailing list, but instead it's a database of qualified decision makers who buy creative services, customized to your marketing criteria.

Let's say you want to target high-tech corporations in the southeast who spend $20,000 to $300,000 annually on design services. You'd get from The List® a database of specific people to call, including direct phone and fax numbers and E-mail addresses, as well as gross billings, number of employees, who's who and what they do.

Morgan Shorey, president of The List®, says they research a list the way you would do it for yourself. They mine the data by making phone calls—lots and lots of them—not only to verify the information, but to qualify these prospects and to find out who the real decision makers are and what they buy. That's what makes it worth the fee, which is in the range of $750 to $3,000 a year for an average of 700 to 3,000 names.

The List® is available in a variety of formats: binders, labels or on disk (Mac and PC, and importable into most contact management programs, including Symantec ACT! and FileMaker Pro).

[*resource*]

The List®

www.thelistinc.com

(404) 814–9969

THE LIST.

GET THERE FIRST.

HOME | CORPORATE LISTS | AGENCY / DESIGN FIRM LISTS | FORMATS AVAILABLE | PRICING

WHAT IS THE LIST®?

THE LIST® is a personalized source of new business leads for advertising and public relations agencies, graphic designers, writers, photographers, illustrators, printers, paper merchants and virtually anyone who wants to reach the decision-makers across the U.S. who hire creative professionals.

PRICE YOUR LIST RIGHT NOW! LIST QUOTE

WHY THE LIST®?

We are not like the directories you have used before. We use directories, city business journals, research magazines, as well as internet research as a starting point.

You're paying for what happens next: we get on the phone with each corporation, agency and design firm, not just verifying, but qualifying, interviewing to find out who the real decision-makers are. These are the names that end up on our list. We do it the way you would do it.

WHO IS ON THE LIST®?

Criteria for inclusion in THE LIST® are thoughtful and thorough. We include corporations with $100 million in gross revenues and above that demonstrate spending power on creative services.

In geographic or industry-specific areas that warrant it, we will include corporations with $25-50 million in gross revenues. Agencies and design firms are selected based on revenues, but also on their inclusion in public arenas including awards magazines and the advertising press. Our endeavor is to qualify the value of the companies we include.

HOW IS THE LIST® DIFFERENT?

There are three primary factors that differentiate THE LIST® from other new business leads services:

1. High Quality Data:

CHRIS SHUMAKER

Vice President
Director of Business
Development

The Martin Agency

"As a national agency, we need to be talking to large numbers of prospects at all times. Nothing is worse than missing an opportunity that would have been a perfect fit. Keeping the prospect list is tedious, and THE LIST® helps take the pain out of the process!"

Photo by
Tony Sylvestro

The List® (www.thelistinc.com) offers a customized database of prospects for creative professionals.

One of the biggest challenges is reaching the actual marketing and communications directors who buy your creative services. Offline, you can rent a direct mail list specified by job title or attend industry-oriented marketing events or educational seminars where they are likely to go. But they may not yet be surfing the sites through which you are promoting your services.

The Internet is becoming a place where people can go to get answers from others within their industry. You can find (and "meet") these people in online discussion forums or bulletin boards. Many people log on to these interactive forums looking for help, advice and resources, which can often translate into work opportunities. Here's a sample post to the *HOW* magazine forum:

Date: 6/20/00 7:58:05 PM
Author: Saralyn
Subject: Seeking web designer in LA area

Hello,

Our company is currently in need of recommendations for web designers/programmers that can assist us with our company's website. We are located in the Los Angeles area, and need to find someone ASAP.

Any ideas?

If you are there to participate, you might be able to either offer your own services or make a referral. This kind of networking can be just as effective (and is usually more convenient) than networking in person.

Jeff Fisher of Jeff Fisher LogoMotives spends time every day logging on to design and marketing-related discussion forums, such as the *HOW* magazine forum, the *Fast Company* forum and the Graphic Design Forum at About.com. These are just a few places in cyberspace where people discuss business and design issues, so when Fisher puts in his two cents, he's sharing his experience, offering resources and positioning himself as an expert in his field. Plus, by way of his sig file, he's providing all the contact information necessary, just in case someone likes what they read and wants to go a little further or talk about a specific upcoming project. In response to a question about getting started in corporate identity, Fisher replied:

```
    Well, first of all, you need to have a
client who is looking for an identity....
    I know that sounds simplistic, but it
is actually the case. Logo and identity
design has always come easy to me. While
in design school in the late [19]70s my
fascination with logo and corporate
identity began. When I got out of school
many such projects began to come my way.
It was not until about six years ago
that I seriously focused on identity as
the primary product of my business.
    Part of the process is learning every-
thing you can about logo design, identity
and branding. Some of the resources out
there include the following books:
```

Designing Corporate Identity Programs for Small Corporations by David E. Carter
The Designer's Guide to Creating Corporate I.D. Systems by Rose DeNeve
Designing Pictorial Symbols by Nigel Holmes
What Logos Do and How They Do It by Anastatia R. Miller and Jared M. Brown

```
    There are plenty of books that show
examples of logo, letterhead and col-
lateral design. I have a good list on
my Web site (http://www.jfisherlogomo-
tives.com) at the "Books/Publications"
page. Far from a complete list, those
mentioned are ones that feature exam-
ples of my work. You might also want
to check out:

    The Graphic Design Book Club
    http://www.howdesign.com/gdbc/

    Good luck!—Jeff
```

Terry Edeker, of Edeker & Edeker Design in Alabama, contacted Fisher after seeing his resourceful postings on the *HOW* magazine forum. "We frequently scan and read forum sites for the purpose of offering professional recommendations, but also with an open mind to new business opportunities. This is how I came to meet Jeff Fisher."

"Our firm has been in need of talented designers who understand the business of design. Locally, we do not have such resources. In reading Jeff's responses to the many corporate identity questions posted in the *HOW* forum, I realized that he approached his business in a very similar manner. So we contacted him."

This could only happen in cyberspace. Fisher and Edeker would never have connected, much less known about each other, in the "real" world. But in this new realm where people come together to share information over a certain topic, important connections are being made every day, even in the middle of the night.

Judy Litt, the About.com guide to graphic design, has some advice for anyone who wants to participate in her graphic design discussion forum. "Don't lurk, post [your questions and comments] and people will get to know you. Once they know you and respect your opinions, they're more likely to visit your Web site."

But is it worth it? Should you take some of your already stretched-to-the-limit time and invest it post-

ing messages in a couple of online communities? According to Litt, "Posting to forums for designers is passive marketing because the majority of people visiting the forum are other designers. However, people looking for designers will also visit the forum. And other designers sometimes need to subcontract work. So a few minutes of your time on a daily basis could eventually have a big payoff." Like all networking, the more time you put in, the higher your visibility and the more you will get out of it.

A good place to start looking for your prospects online is Web sites that cater to online business communities. Some of them—Onvia.com, *Fast Company* and *Red Herring*—have discussion forums. Check out industry-specific sites too: Verticalnet (www.verticalnet.com) is a network of sites that caters to top engineers and executives in more than thirty industries. Sites included within the network include www.oilandgasonline.com, www.pharmaceuticalonline.com, and www.hospitalnetwork.com. Visitors to these sites are not just browsing; they are there to gather important business information, and they are probably decision makers at their companies.

[*resource*]

DESIGN-ORIENTED DISCUSSIONS

HOW Magazine Forum (www.howdesign.com)

About.com Graphic Design Discussion
 (http://graphicdesign.about.com/)

Creativepro.com (www.creativepro.com)

The DesignForum
 (www.mediadrone.com/forum)

The Designers Network (www.designers-
 network.com)

Art Talk (www.Theispot-Showcase.com)

CORPORATE- AND BUSINESS-ORIENTED DISCUSSIONS

Fast Company Magazine
 (www.fastcompany.com)

Red Herring Magazine (www.redherring.com)

Verticalnet (www.VerticalNet.com)

Onvia.com (www.onvia.com)

Delphi Forums (http://forums.delphi.com)

Unless your timing is impeccable and luck is on your side, the tools discussed so far in this chapter are not a means of reaching prospects in their moment of need. The eLance Web site (www.elance.com), a sort of eBay for services, attempts to provide a forum for this kind of key, time-sensitive buyer/supplier connection.

While eLance offers a traditional directory of services and free portfolio space, most of the activity can be found where the "auctions" take place. It works like this: In the "RFPs" (Requests for Proposals) sections, buyers (people with needs)

from around the world post the details of their projects (many of which are Web related), including an estimate of the fee they want to pay. "E-lancers" (people with services) bid on those projects with a miniproposal, links to examples of their work, and an offer of the fee they would charge to do the project. At the time of this writing, eLance is still in its testing stage and doesn't cost anything to either party, but the company plans to charge minimal fees to both the buyer and the seller for using the site.

The home page of eLance (www.elance.com), an online auction site.

The "Creative" section on eLance (www.elance.com) lists available projects.

Jennifer Thoden of Thoden Design has found eLance to be a strong marketing tool. "Bidding on jobs is much more effective than posting my services," says Thoden. "I've been awarded quite a few, and those clients have become long-term clients." One of those is David Li, of ClickBenefit, Inc., who hired Thoden Design to do a $10,000 Web design project for his Internet startup and considers himself a regular customer on eLance. It's far from a perfect process, though; one of the disadvantages is that buyer and seller have no direct contact until the buyer chooses a "winner." "I have to choose a seller based on their portfolio and the messages they leave on the message board where we communicate. This makes the process of checking references and talking to a number of sellers more difficult than using the yellow pages." Hilary Krant, Director of Marketplaces at eLance.com, explains that the site is an open marketplace that offers best price discovery and best competition when all the information is shared among all participants. "If we allow people to communicate offline, they're providing information to some and not to others."

Both Thoden and Li chalk up these inconveniences to the fact that online auctions are still relatively new, and they continue to use the site. Thoden has been awarded enough well-paying work with quality clients that she spends an hour a day posting her bids. And Li finds the easy, quick, interactive access to a potentially large talent pool difficult to walk away from. "I have found some good designers, like Thoden Design."

Terry Edeker, of Edeker & Edeker Design, has also participated in many bid sites and has found that the clients who solicit services there are often looking for the lowest price rather than value. Zerita Rodriguez, of Denver-based Black Lava Graphics, used eLance quite a bit when it first arrived on the scene but no longer relies on the site for business. "At first, I thought it was OK to work below my normal rates because there were no meetings to go to," says Rodriguez. "So I started bidding on projects and got a few good ones. But then, there was a huge influx of people offering services for practically nothing. Now, it's just a big flea market for services, and it's not worth my time." Thoden knows what Rodriguez and Edeker are talking about, but she won't let eLance drive her prices down. "I have been the highest bidder on two of the projects I've been awarded, and most clients have commented that they chose me because of high-quality design."

Whether auction sites will become a new way for clients and creatives to make connections is yet to be seen, but the concept does hold some promise, and auction sites are popping up now in all kinds of industries. And for the creatives who devote their time to it, it seems to be working.

[*resource*]

ONLINE AUCTION SITES

www.elance.com

www.guru.com

www.freeagent.com

www.iniku.com

www.monster.com

www.uscreative.workexchange.com

"We get an average of five serious new leads a day through our Web site."

Bill Keaggy, XPLANE
(www.xplane.com)

The people who can give you the most useful information are those who take the time to visit your site, and that's the perfect time to ask them for a few details about themselves. The worst thing they can do is say "no" with a click. Bill Keaggy, creative director at XPLANE, estimates that 95 percent of their new clients contact them first through their simple online contact form.

A prospect is asked to provide the name of the company, E-mail address and Web address (but not the mailing address), their favorite Web site, how they found XPLANE, and a description of the business/project they have in mind. "It seems that nearly everyone comes to our Web site before contacting us because they want to see our online portfolio. The majority of them do become clients." You can

either create your own form, use the familiar guest-books, or use Response-O-Matic, one of the many free services available online. Your best chance of getting your prospects to fill out your form is to make it easy and quick. Ask only for basic information, and be sure to tell them what you'll do (or would never do) with their information.

Filling out a contact form should not be confused with registering before you can enter a Web site. Research has shown that when people have to register, many don't.

[*resource*]

www.response-o-matic.com
Free and simple scripts to create forms on your Web site.

The contact form on the Web site for XPLANE (www.xplane.com) gathers basic information from prospects.

If you have a Web site, tracking traffic is one of those marketing tasks you know you should be doing, but perhaps aren't. You probably get (or at least have access to) Web reports, but maybe you don't take the time to look at them; or if you do, you can't make heads or tails of the data. But the information on your Web reports can be used to make changes that improve the marketing power of your Web site—leading more potential clients where you want them.

What's in a Log?

Log files are records of all the visitors to your Web site. They tell you where your visitors are coming from, what they're doing on your site, how long they stay, which files they download, etc. This information can help you understand what your visitors want to see, as well as point out navigational problems. Most Internet service providers (ISPs) offer access to your log files as part of the monthly hosting fee; they are sometimes sent automatically, or you can go get them. These reports can provide the information in both text and graphic formats. If this data isn't offered by your ISP, there are free services that provide it.

WHERE THE HECK ARE YOUR LOG FILES?
Bravenet.com is a free hit tracker used by illustrator Michael Wertz. Their logo is on his Web site, and all he has to do is click on it if he wants to see his Web report.

Counter Statistics: Last 50 Visitors

#	Time	IP	Host	Referer	OS	Browser
1	2000-02-28 08:07:51 PM	208.160.180.27	webdev.isni.net	http://www.commarts.com/creative/cre_sr.html	Windows 98	Explorer 5.01
2	2000-02-28 08:06:29 PM	216.7.177.201	dialup-216-7-177-201.sirius.net	bookmarks	Mac OS	Netscape 4.5
3	2000-02-28 07:52:11 PM	216.164.190.80	216-164-190-80.s80.tnt1.nek.nj.dialup.rcn.com	Direct Hit	Windows 95	Explorer 5.0
4	2000-02-28 07:38:21 PM	206.24.101.31	gateway.gap.com	http://dir.yahoo.com/Regional/U_S__States/California/Cities/San_Francisco/Entertainment_and_Arts/Art	Windows NT	Netscape 4.5
5	2000-02-28 05:31:28 PM	205.134.244.75	ppp-asok02-075.sirius.net	Direct Hit	Mac OS	Netscape 4.05
6	2000-02-28 04:57:17 PM	193.214.63.137	kappa8.aktiv.no	http://search.msn.no/spbasic.htm?MT=design&UDo=no&L/enorwegian&CO=10&UN=doc	Windows NT	Explorer 5.0
7	2000-02-28 04:43:53 PM	192.232.120.194	proxy1.kodak.com	http://www.astrocat.com/frames/foslinks_artists.html	Windows NT	Explorer 5.01
8	2000-02-28 04:39:14 PM	216.7.177.39	dialup-216-7-177-39.sirius.net	Direct Hit	Mac OS	Netscape 4.5
9	2000-02-28 04:04:03 PM	212.234.44.35	212.234.44.35	http://www.budpeen.com/news%20pages/ness.panel.link.html	Windows 98	Explorer 5.0
10	2000-02-28 02:26:40 PM	155.44.98.192	rudolphpmac.hmco.com	Direct Hit	Mac OS	Netscape 4.7
11	2000-02-28 01:50:21 PM	141.50.248.24	ketho.akad.med.uni-giessen.de	http://www.commarts.com/creative/cre_sr.html	Windows NT	Explorer 5.0
12	2000-02-28 09:52:34 AM	210.108.233.230	210.108.233.230	http://dir.yahoo.com/Regional/U_S__States/California/Cities/San_Francisco/Entertainment_and_Arts/Art	Windows NT	Netscape 4.03
13	2000-02-27 11:33:40 PM	67.102.11.1	67.102.11.1	http://www.lorib.net/	Windows 98	Netscape 4.7
14	2000-02-27 11:09:38 PM	192.95.188.2	192.95.188.2	http://dir.yahoo.com/Arts/Visual_Arts/Illustration/Artists/Personal_Exhibits/	Windows NT	Explorer 4.01
15	2000-02-27 10:40:11 PM	216.7.176.155	dialup-216-7-176-155.sirius.net	Direct Hit	Mac OS	Netscape 4.5
16	2000-02-27 09:12:40 PM	63.198.195.166	adsl-63-198-195-166.dsl.snfc21.pacbell.net	mailbox:/sys.app.util/System%20Folder/Preferences/Netscape%20Users/./Mail/Inbox?id=c03007901b-4d116e4	Mac OS	Netscape 4.7c-cokmod
17	2000-02-27 09:01:10 PM	63.198.195.166	adsl-63-198-195-166.dsl.snfc21.pacbell.net	mailbox:/sys.app.util/System%20Folder/Preferences/Netscape%20Users/./Mail/Inbox?id=c03007901b-4d116e4	Mac OS	Netscape 4.7c-cokmod
18	2000-02-27 08:45:24 PM	216.7.176.175	dialup-216-7-176-175.sirius.net	mailbox:MED/Amonte2000%AW/System%20Folder/Preferences/Netscape%20Users/Brian%20Murphy%20%28monte%29/	Mac OS	Netscape 4.5
19	2000-02-27 08:43:14 PM	206.169.225.108	japan-108.ppp.hooked.net	http://www.gag.org/sanfran/links.html	Windows NT	Netscape 4.7
20	2000-02-27 06:59:25 PM	205.188.192.169	spider-ab044.proxy.aol.com	undefined	Mac OS	AOL 4.0
21	2000-02-27 05:29:07 PM	208.2.209.108	ip208.2.209.108.go-concepts.com	http://www.dogpile.com/texis/search?q=wertz&geo=no&fs=web	Windows 98	Explorer 5.0
22	2000-02-27 04:59:20 PM	212.163.214.219	1Cust219.tnt5.rtm1.nl.uu.net	http://www.gag.org/portfolio/portfoli.html	Windows 98	Explorer 5.01
23	2000-02-27 04:54:55 PM	152.163.197.201	spider-tf061.proxy.aol.com	Direct Hit	Mac OS	AOL 4.0
24	2000-02-27 04:44:02 PM	203.67.192.11	203.67.192.11	http://www.commarts.com/creative/cre_sr.html	Windows 98	Explorer 5.01

[resource]

TRACKING SOFTWARE RESOURCES

www.extreme-dm.com/tracking/

www.bravenet.com

www.webtrends.com

Illustrator Michael Wertz (www.wertzateria.com) gets his Web reports from Bravenet (www.bravenet.com), and they give him valuable information about where visitors are linking from.

BUD PEEN / CUBIT

The home page of illustrator Bud Peen's Web site is a site map (www.budpeen.com).

You could call illustrator Bud Peen a real Webmaster, because since 1994 he has actually mastered his Web site, www.budpeen.com (now in its sixth iteration). By reviewing his log files religiously and analyzing and interpreting the numbers, he has come to understand the needs of his visitors and has made changes and improvements in response to them so that his Web site is the most effective marketing tool it can be.

"It's fascinating to be able to track and quantify someone's visit through my site. The Web reports make me take my site more seriously, and they clearly show, in a way that is impossible with mailings or other advertising, what works and what doesn't."

Bud Peen (www.budpeen.com)

Create Your Own Report

Bud Peen's home page is basically a site map, so at first glance visitors can see clearly what their options are, instead of having to guess at what is "behind door number one." "I've designed the site to get you to the pages you need to see as quickly as possible," Peen writes to his visitors in an introductory page on the site. "I've avoided the plug-ins and animation as a trade-off to faster access." Thanks to the easy navigation, it is not an overwhelming experience.

From his Internet service provider, Peen gets a weekly Web report that typically runs thirty pages. Here's a sampling of what Peen learns from this report:

• **Where visitors go from the home page.** "When designing the site," says Peen, "I assumed people would go directly to the 'News' part of my Web site first. Instead I have found that most people go directly to the editorial section of my illustration portfolio. This tells me that most visitors know of my work and shows me that the site is doing what it's designed to do: display my work."

• **How deep visitors "drill" into the portfolio.** Peen wants his visitors to see at least five or six images in each of four sections of his illustration portfolio—editorial, corporate, institutional and 3-D. "If a large number of hits register in the first image, but not the second, I know the first image needs to be changed to get people to go further into each portfolio."

• **Which Web sites visitors come from.** "Links from other artists' Web sites are extremely helpful in guiding viewers to my site. So are links from Web site awards, professional organizations and gallery shows on corporate or private sites."

• **Which countries visitors come from.** A typical weekly report shows hits to Peens' site from countries all over the world, including France, Belgium, South Africa, China, Mexico, Thailand, Brunei, Malaysia, Saudi Arabia, Croatia, the Netherlands, Japan, Austria, Ireland, Poland, Iceland, Turkey, Taiwan and more. Says Peen, "That's a lot more people reached than by direct mail!"

Some of the categories on the Web report are simple and self-explanatory. Others need to be deciphered in order to reveal any real information. That's the case with a section of the report called the "Request Report," actually one of the most useful sections if you can mine the data. The Request Report shows the number of hits for each page, button or image—a clear indication of what visitors are most interested in. The problem is that this report gives so many listings that it's confusing. So Peen has created his own tracking form to interpret the information.

The more time you spend interpreting the report, the more information you'll glean. Peen suggests starting out by printing out the Web report and highlighting the important info. "If you do that for two or three reports, you'll soon learn the information that's important." He also offers this hint: "Most ISPs that offer the reports also have information at their site as to how to interpret them." So don't assume you're on your own; help is available. But don't obsess over your log files because, as Peen himself points out, "The real gauge of success for a Web site is how many jobs derive from it, and you don't need a Web report for that."

Become a Web Master

Are you a master of your own Web site? If so, here's what you need to know:

- How do visitors find your site in the first place?
- How many make it past the main page?
- Which page is the most popular?
- How long does the average visitor stick around?
- What is the average number of pages viewed?
- What path do visitors take through your site?
- What links do they use to leave your site?

Source: **Internet Marketing Challenge**

☐ **PERSPECTIVE** ☐ **CONTACT** **DATE:** _____

── NEWS ──

☐ news.book.html
☐ news.id.html
☐ news.lecture1.html
☐ news.project.html
☐ cringleydock.html
☐ cringleyfalcon.html
☐ cringleyoffice.html
☐ cringley.html
☐ cringleycorpse.html
☐ cringleyconfess.html
☐ cringleyglass.html
☐ olympia.html
☐ news.link1.html

── PORTFOLIO ──

EDITORIAL

☐ bear.html
☐ skier.html
☐ cringleydock.html
☐ gunslinger.html
☐ nude.html
☐ inspection.html
☐ holiday.html
☐ newyearseve.html
☐ scientist.html
☐ ransom.html
☐ anxiety.html
☐ walker.html
☐ madonna1.html

CORP.

☐ carwash.html
☐ javaposter.html
☐ embarcoangel.html
☐ tshirt.html
☐ tshirtsprd.html
☐ wellsfargo.html
☐ snack.html
☐ skater.html
☐ tourism.html
☐ chevron.html

INSTITUT.

☐ treebanner.html
☐ streambanner.html
☐ hikerbanner.html
☐ homebanner.html
☐ antiquarian.html
☐ artcomm.html
☐ artcomm2.html
☐ artcomm1.html
☐ btob1.html
☐ btob2.html
☐ btobmerch.html
☐ jammin1.html

3-D

☐ caropener.html
☐ carspot1.html
☐ carspot2.html
☐ carspot3.html
☐ msoffice.html
☐ pigtrophy.html
☐ trophy.html
☐ publish.html
☐ guitar.html

BOOK

☐ pipercov.html
☐ initcap.html
☐ piperappear.html
☐ piper+rats.html
☐ hamelin.html
☐ lameboy.html
☐ bulbcov.html
☐ crocus.html
☐ fairybells.html
☐ meadow_saf.html
☐ paperwhites.html
☐ soleil.html
☐ maccov.html
☐ macsys.html
☐ macdaisy.html
☐ pccov.html
☐ pccomputer.html
☐ pclaptop.html
☐ pcvideo.html
☐ pcergo.html
☐ merc.html
☐ litsf.html
☐ coffee.html
☐ courtcov.html

── INDUST. DESIGN ──

LAMPS

☐ bayonet.html
☐ bayonet1.html
☐ bayonet2.html
☐ asterisktable.html
☐ asterisk.html
☐ asteriskflr.html
☐ conica.html
☐ conicaflr.html
☐ feathers.html
☐ skyscraper.html
☐ cat.html
☐ dog.html
☐ sheraton.html
☐ leaves.html
☐ chin1.html
☐ argus.html
☐ roulinflr.html

FURNITURE

☐ chinbed.html
☐ chindesk.html
☐ chinarm.html
☐ console.html
☐ mirror.html
☐ spkconsole.html
☐ legbox.html

PANELS

☐ vase2.html
☐ vase1.html
☐ blossoms1.html
☐ blossoms2.html
☐ nudepanel.html

ACCESSORIES

☐ carrgclk.html
☐ cirqueclk.html
☐ rippleclk.html
☐ clockdes.html
☐ msoffice.html
☐ jardnumbs.html
☐ russnumbs.html
☐ firescreen.html

── BIO ──

☐ bio.awards.html
☐ bio.clients.html
☐ bio.pubs.html
☐ bio.books.html
☐ bio.mail.html

Illustrator Bud Peen made this customized tracking form for his Web site because his Web reports were too complicated.

Learn From Your Log Files

By tracking the traffic to and on your site, you can tweak your site for maximum effectiveness. All that information—and a lot more—is in your log files. Here's what you can learn:

1. **What:** Do you know which category in your portfolio is most often viewed? It may not be what you think. Your log files can tell you what your online market is looking for, then you can give them more of it.
2. **Where:** Referrer pages tell you whether your visitors are coming from a search engine, another Web page (that has a link which you may not even know about) or a link from your sig file. A direct hit tells you that instead of linking from a Web page, the visitor typed your URL into the address bar, which means your offline marketing is doing its job.
3. **When:** If, as part of your E-mail marketing campaign, you send out an E-mail message with a link to your Web site, your Web reports will tell you how effective your E-mail message was at driving visitors to your Web site. If the report shows an increase in hits the day your E-mail message was sent, it worked!
4. **How:** If visitors are finding you through search engines, your log will tell you which keywords brought them there—information that you could otherwise only speculate about.

chapt

chapter 8

xpos

XPLANE NEWS | **J O B S** | XBLOG

working on the web

By now you can see that the Internet is a very powerful marketing tool, but it is much more than that. It is fundamentally changing the way we do business. First and foremost, doing business is now easier and faster for all involved, whether you have a Web site or not. E-mail alone has made day-to-day business much more efficient. It is often the quickest way to answer the questions of clients or potential clients, get information and respond to requests without wasting anyone's time. And for some, face-to-face meetings are practically a thing of the past.

The Internet has also made possible relationships and working arrangements that were unthinkable before. It has created an unlimited and global market for work. A one-man band in Australia can now work for a client located literally anywhere in the world without ever leaving home, without ever meeting the client, and in several cases without ever talking with the client on the phone. Also, the networking benefits of the Internet can be essential to those who work alone in a home office.

These new opportunities that take the Internet beyond the realm of marketing can at the same time be used to your marketing advantage. If you are set up to use the latest technology, you automatically have an advantage over those who are not adopting and adapting as quickly.

In this chapter, we'll look at the way designers, illustrators and other creatives are making their professional lives easier by working "virtually": using the Web to collaborate with clients and colleagues in ways that were not possible before, as well as to recruit employees and manage behind-the-scenes details.

Work Virtually With Clients and Colleagues

"E-mail has become my primary source of contact with clients locally and throughout the country."

Jeff Fisher,
Jeff Fisher LogoMotives
(www.jfisherlogomotives.com)

Working electronically with everyone from new prospects and clients to vendors has changed the way designers do their work. You can send and receive text files immediately, E-mail graphic files of rough designs for review, give and get immediate response to questions and obtain quick approvals on projects. Designers are producing complex projects without ever talking with the client on the phone, because the technology enables a kind of communication that makes people more comfortable with colleagues in far-flung places than they ever have been in the past. That was the case when David Curry Design created the Web site for the United Kingdom-based software company Compware. "To this day we have never spoken by phone or exchanged regular mail. The site design program was developed entirely over the Internet, and we corresponded solely by E-mail."

Romania-based Grapefruit Design (www.grapefruitdesign.com), a virtual company made up of people on three continents, also would not have been possible without the current technology. Marius Ursache teamed up with a few other creatives and formed a virtual creative agency, Grapefruit Design, that works using only the Internet, although they do not design only Web sites; they also produce corporate identities, ads,

package design and more. With headquarters in Iasi, a city in northern Romania, Ursache, executive creative director, works with his project manager and chief Web developer. Their permanent staff includes a PR consultant in Miami, Florida, and a copywriter in New Zealand. They hire freelancers from all over the world to work on specific projects.

The online collaboration is all made possible by the electronic tools that facilitate communication—such as ICQ, AOL's Instant Messenger, Internet phones, video conferencing and FTP (file transfer protocol)—all of which gives them greater control, greater access and greater independence. "Working with a company thousands of miles away and using only E-mail and ICQ seems to be a daring step. But our clients are very pleased working with us this way," says Ursache. "They get everything they need really fast because we can make changes and submit the revised work quickly. The relationships with clients are a lot more relaxed and pleasant, not to mention that this way of communicating helps us reduce our fees, which also benefits our clients."

[*resource*]

You can download the ICQ application free of charge from this shareware site: www.tucows.com

Give Clients Online Access to Work in Progress

Los Angeles-based Top Design Studio uses their simple Web site to work with clients around the world. Principal Peleg Top claims that one of his most high-profile projects, a recent CD design project for singer Patti LuPone, would have been impossible without that Web site. "Since LuPone is on tour all the time, she can't meet with us, but she can view the Web site from London, Austria or anywhere she is. So we submitted the artwork for review online. We never met face-to-face until the project was finished."

Top simply posts the work in progress on a private URL on their Web site and gives the Web address to the client. "We don't have to make and send color proofs. The client prints out as many copies as they want. This saves a lot of time, and we get back a revised version that we can finish." Posting the work online may, by now, be common knowledge and practice to many creatives, but don't assume that your clients understand the benefits of the technology. "Lots of clients don't know this can be done," says Top. "Once we tell them, they think it's the greatest thing, which gives us lots of Brownie points." Educating them on the technology and spelling out the time and money savings will give you a marketing edge and make your job easier as well.

Top Design Studio posts their work in progress on a special Web site, then they give the Web address to their client, who can access it from anywhere around the world.

Collaborate With Clients and Colleagues Online

While reviewing work online and communicating via E-mail are great in and of themselves, the Web has made it possible to go even further. The watersdesign.com Web site has client workrooms, which are located on a private, password-protected section of the Web site and offer much more than the ability to view work in progress.

"We include everything from a contact list to a discussion forum where members of the team can meet to discuss the various elements of a project," explains Andy Austin, director of communications. "We also include links to research and competitive information when that's useful."

If you don't have (or just don't want to spend your time creating) the technological infrastructure to collaborate virtually, some Web sites offer these services. Calling itself the "ultimate destination for marketing and creative professionals," MarketingCentral (www.marketingcentral.com) offers collaboration applications that give its members their own secure intranet. The service is designed to allow project teams from anywhere in the world to share documents, files, notes, proofs and feedback. Everyone involved in a project gets round-the-clock access. In addition, a feature called the "integrated task manager" makes it easy to assign and coordinate activities, so that nothing falls through the cracks. It's especially good for small agencies and for firms with offices around the world with freelancers or clients in other time zones.

Phil Scopp, principal at Atlanta-based design firm Creative R&D, was involved in the early stages of development of MarketingCentral and has

used their "Collaborate" feature for several years to post comps, budgets, schedules and messages, which his clients can access from anywhere with a user ID and password. "We can all be viewing and commenting at the same time. The clients like it because they can go to the site and collaborate among themselves, even if we're not involved."

Though the Web makes everything easy and quick, there is a price to pay. One of the problems associated with reviewing any graphic online is color fidelity. "It's fine for electronic work that will end up on the Web, but we're doing multidisciplinary branding. The colors sometimes look drastically different online than they would in print."

A client workroom on the watersdesign.com Web site allows collaboration on a project from anywhere in the world. On the left navigation bar is the running list of presentation updates, and the image on the right is one of three versions presented to the client.

Recruit Employees Online

The Web is also an effective recruiting tool. Although many clients aren't yet automatically surfing the Web when looking for creative professionals, many job seekers think first to look online for work. This is spurred on by the proliferation of online recruitment agencies encouraging everyone to do their job hunting online. XPLANE, a St. Louis-based information graphics firm, does the majority of their recruiting online. Their Web site, www.xplane.com, devotes a lot of space to recruiting. For starters, on the home page, the *N* of XPLANE blinks like a neon sign with the words "We're Hiring."

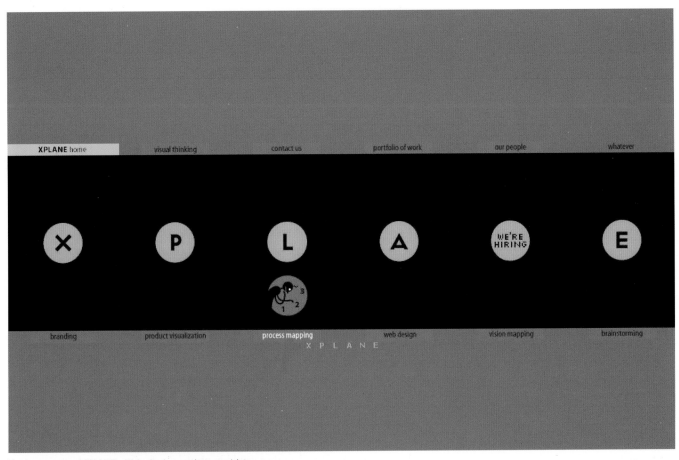

The home page of XPLANE's Web site (www.xplane.com) lets visitors know that the company's hiring.

The recruiting section of the site welcomes visitors with a message that would appeal to anyone: "XPLANE is a place where, essentially, you can design your own job." Job descriptions are well written, entice potential hires with phrases such as "no two days will be alike" and highlight the benefits offered, such as health coverage.

"A lot of smart creative people are stuck in jobs where they're told what to do, so they appreciate the freedom we offer," says Dana Moore, XPLANE's human resources manager. Moore receives a lot of job inquiries from people who have become fans of XPLANE from their "ant people" graphics in the offline magazine *Business 2.0*. In fact, Moore estimates that a third of the calls she gets are due to their credit line in the magazine, which also happens to be their Web address.

XPLANE posts their job openings on other Web sites as well, such as the job listing database on the Web site for the Society for News Design (www.snd.org), the St. Louis chapter of the AIGA (www.aiga-stl.com) and several local universities. "A lot of people also hear about our jobs through plain old word of mouth," says Moore, but in truth it's mostly "word of Web," because XPLANE makes it easy for anyone who visits the site to send the URL to a friend.

While finding people online (or helping them find you) works best for Web-related positions, Moore prefers to find employees online for administrative jobs as well, "because that tells me they're comfortable with the computer, which they're going to use every day."

XPLANE's Web site has a separate
section devoted to recruiting.

Like everything new, all the tools made available through technology have their limitations; instead of replacing the old way of doing business, these must instead be integrated into it. In the April 2000 issue of *HOW* magazine, Lorne Cherry, president of Ontario-based Computer Graphics Direct, writes, "Electronic tools bridge international borders, bringing you business that would otherwise be unobtainable, or at least not very cost effective. But designers who use these e-tools report that when it comes to creative collaboration, technology enhances—but doesn't replace—good, old-fashioned personal contact."

How to Use Your Web Site as a Recruiting Tool

Develop your Web site with not only clients in mind but prospective employees, freelancers and interns as well. Use it to provide initial information for someone who is considering applying or interviewing. In addition to seeing examples of your work, prospective hires will want to know

- **What jobs are available: Include both general and specific positions.**
- **What it's like to work there: Portray the work environment with photos and testimonials from current employees.**
- **What benefits are offered: Offer details about health benefits and other perks.**
- **What advancement opportunities are available: Describe any training offered, as well as career-advancement possibilities.**
- **Who to speak with: Provide specific contact information for prospective employees.**

section.four

WEBSITE

CITY, USA TEL 212.226.6024 FAX 2

GRAPHIC
IDENTITY ILLUSTRATION

IGN

1997

ENTS E-MAIL INFO

©1997 MIKE QUON / DESIGNATION , INC.

the complete online

the complete online marketing plan

marketing plan

chapt

chapter 9

DESIGN

GRA
IDE

© MIKE QUON DESIGN OFFICE 1997

CLIENTS E-MAI

ALL IMAGES ©1997 MIKE QUO

fitting online marketing into your life

It's rarely just one thing—a mass mailing or a visit to your Web site—which prompts someone to hire you. All marketing tools, online and offline, work together, often complementing and supporting each other. Prospects get to you by a number of venues, an accumulation of messages which motivate them, mysteriously sometimes, to pick up the phone or send you a message that says, "I've got a project." And most of it has to do with timing, luck and their moment of need.

Your overall marketing plan should include all the things you have already been doing to market your services plus a few of the electronic tools that you've read about here. Here are a few strategies creative professionals have used to completely integrate all of their marketing tools to generate more work.

"I'm a big believer in the ongoing marketing plan. You have to be there all the time; you can't do it once and then hope."

Ivan Levison, direct response copywriter (www.levison.com)

As soon as illustrator and designer Ilena Finocchi secured her domain name, www.ifid.com (for IF Illustration & Design), she posted a basic Web page showing one of her dimensional illustrations and providing all the different ways to contact her. She didn't really plan on having that temporary page up for an entire year, but the Web site creation process has not been quite what she expected. "I was going to have more fun stuff on my site," says Finocchi, "but after visiting lots of other sites and not being able to find what I'm looking for—

like a phone number—I pared mine down and made it more straightforward. It's still well designed, and samples of my work are there, but it's not as unnecessarily funky."

But Finocchi didn't let her own slow process get in the way of her self-promotion, and she didn't wait until her site was perfect (or even finished) to start promoting it. She began by putting her Web address on everything: her stationery, business cards and monthly promotional postcards.

Illustrator and designer Ilena Finocchi's postcard campaign included her Web address, even though her Web site wasn't quite finished.

While her Web site was under construction, illustrator and designer Ilena Finocchi posted a simple page (www.ifid.com) with all her contact information.

These mailings are not meant to launch the Web site; instead they are part of Finocchi's ongoing postcard campaign to promote her illustration and design services. Nonetheless, they generate a lot of traffic to her Web site. "People go to the site when they get the postcards. Then they send an E-mail message asking to see more samples."

At the time of this writing, Finocchi is still working on her Web site, but she's already printed the materials to announce it, so that when it is ready to launch, she can get the word out without delay. Playing off her North Lima (as in the bean), Ohio, location, she's created a whimsical little flip-book called *The North Lima Bean Machine*, in which a lima bean goes through a machine and comes out the other end, holding up the Web address. She'll follow up that mailing with a simple letter and a bookmark that, of course, reminds recipients to bookmark her site.

[*resource*]

Web cards are printed postcards with an image of your Web site. Use them to announce your site, as handouts at trade shows or to follow up with a long-lost client.
www.wbcards.com
(800) 352–2333

IF Illustration & Design's Marketing Tool Kit

- **Monthly postcards**
- **Web site**
- **Dimensional business card**
- **Flip-book**
- **Bookmark**
- **Personal letters**

The last page of Ilena Finocchi's whimsical flip-book has a lima bean holding her Web address.

Ilena Finocchi's Web site launch included printed materials such as a bookmark and her dimensional business card.

www.IFid.com
Bookmark it!

Visitors can sign up to be notified by E-mail when Jed Block's Web site (www.jedblock.com) is updated.

When Jed Block, writer and photojournalist, launched his Web site in June 1999, he sent out a postcard with the following poem:

> Ode to www.jedblock.com
> Maybe you use me.
> Maybe you've not.
> Maybe you've pulled for me.
> Or, you could've forgot.
>
> Whatever the case,
> it was five years this spring
> that I followed a dream
> to try my own thing.
>
> That it's still going
> is reason to cheer
> so I wrote me a Web site
> rather than slammin' a beer.
>
> This card's to invite you
> to sign on and visit.
> I'd like to do more,
> but the budget's a limit.
>
> Please stop by
> www.jedblock.com

It may be a bit corny, but the tone ties into that of his Web site, plus, more important, it drew a lot

of response from the 200 people on his in-house mailing list of prospects and existing customers. Many comments came via E-mail, some referring to the personal work he included on the site—short stories, "pretty poor poetry" and information on a children's book about juvenile diabetes that he's written with his daughter. (Block also received several phone calls from people who weren't yet connected to the Internet but wanted to tell him how much they liked the card.)

Not only did the Web site announcement motivate people to respond, it also generated a few projects. "The advertising manager of an insurance agency hired me to write the agency's new brochure," says Block. "And an executive of a technology firm suggested that I submit a proposal to write a book about their company's history."

Once the Web site was launched, Block knew he had to continue using it as a marketing tool, so he adds new information to the site every week or two. He's also installed NetMind, an E-mail reminder service on his "Current Piece of Work" page for people to sign up to be notified whenever the site changes.

The way NetMind works is simple. All you do to install a Mind-it button on your Web page is fill out a registration form and paste in a few lines of HTML code. NetMind keeps the E-mail list (of people who have signed up to monitor the site) and sends out a simple reminder message.

"It's easy and convenient, virtually automatic and very reliable. It allows me to get people back to my site with minimal effort. And it works. Each time I update my site," says Block, "traffic increases significantly." The only problem is that, according to NetMind's records, only three people have signed up (and Block is one of them), but the increase in traffic to his site following the changes he makes on the site tells him that more people must be on that E-mail list. "Looking into this matter is on my 'to do' list," says Block.

[*resource*]

NetMind's Mind-it
reminder service
www.netmind.com

"Most designers tend to think of using printed matter as the most effective way of promoting ourselves. But it really has to be a combination of things: good direct mail, good portfolio presentations, design competitions, advertising in directories, getting your work show-cased in the media, writing articles, giving speeches and marketing online."

Mike Quon,
Designation, Inc.
(www.mikequondesign.com)

Mike Quon has been promoting his design and illustration services for over twenty years, and he jumped on the online marketing bandwagon as soon as it got going. But that doesn't mean he's stopped the offline promoting. "I like to stay in touch with my top fifty clients and prospects," says Quon. "In addition to wining and dining clients, I've remembered their birthdays and sent thank-you notes in fortune cookies, and cheesecakes. I've even taken them shark fishing—whatever it takes."

He coordinates these nontraditional marketing tools with online tools to solidify his relationships with these people he thinks of as "friends." Having samples of his work online, at his Web site, on port-folio sites such as Theispot-Showcase and on his clients' sites has made meeting with new prospects a much "lighter" process, literally. "I don't even have to bring my portfolio around with me," he says (although he still does). "As long as they have a computer, I can just show them what's online."

This accessibility made it possible for him to land an international ad campaign for KPMG. Over the years, Quon had kept in touch with Xenia Polchaninoff and Peter Cohen, the art buyer and art director, respectively, at Lowe Lintas & Partners, with whom he'd worked on small projects in the past. "What's great about Mike," says Polchaninoff, "is that he never lets you forget about him. He's sent promo cards, cute letters, all kinds of little reminders of himself, which is great. So of course when this project came up, I thought of him right away."

Quon's was one of ten or fifteen portfolios that were called in for a job that needed a pixel-like style of illustration, small digitized pictures that said "computer." When Quon was one of two artists chosen in the final round, he went in to meet with Cohen, art director for the KPMG account, with whom he'd also kept in touch by snail mail, but not as closely.

The home page of Mike Quon's Web site, www.mikequondesign.com.

"He loved my book," Quon remembers, "but I didn't have the look he needed. Because I have so many styles online, I could access some work I did for a computer company that fit what he needed."

Cohen agrees that being able to see the right kind of work online, right there in his office, secured the job for Quon. "I was still waiting to see one other person's book, but it was taking forever. Quon had a couple of stylized drawings on a site that showed me he could do it. Plus he has a very earnest and can-do attitude. So I awarded the project to him."

Of course, Quon plans to use this job as a self-promotion opportunity. A month after the ads run in *The Wall Street Journal,* he'll send out an E-mail message with a live link to a page featuring the ads on his Web site.

Mike Quon's printed promotional materials support his online marketing.

Walking Billboards Are a Good Thing

Walking billboards are one of the marketing tools that Swiss illustrator and graphic designer Albin Christen is using in his online marketing plan. Anyone who visits his Web site can request a free T-shirt, adorned with one of his illustrations, of course, and his URL (www.albin.ch).

Christen is also listed on DesignScout.com, the online database of design firms, and his free T-shirt offer was advertised in DesignScout's monthly E-mail newsletter, which goes out to designers and marketing executives. He also gives them away to friends and prospects who visit his studio. Recipients of the T-shirt also get a set of promotional (but quite useable) postcards featuring his fanciful illustrations.

Results? After two months, Christen received twenty-six orders for the T-shirt (six from the United States as a result of the DesignScout mention and twenty from France and Switzerland)—not bad for an initial step toward promoting himself in the United States. Now he'll have to follow up with those prospects and keep his name in front of them if he wants them to remember him and think of him in their time of need.

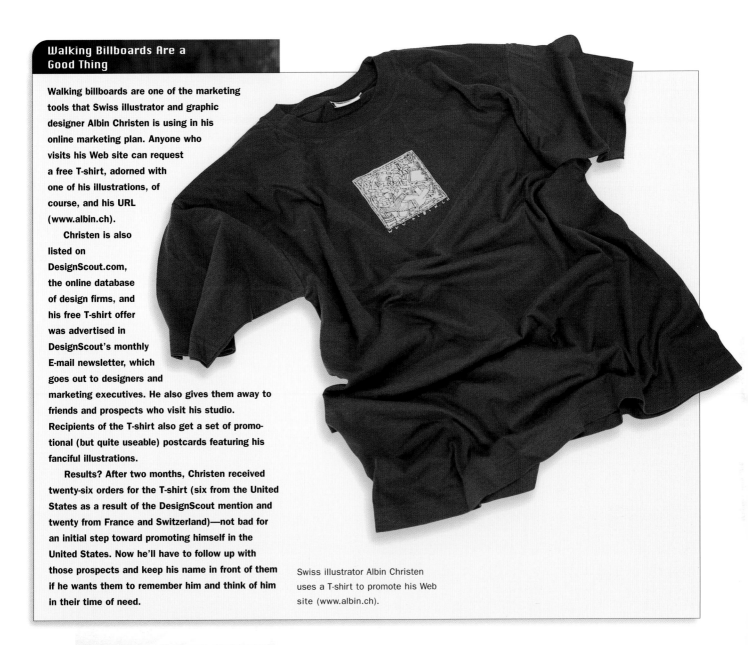

Swiss illustrator Albin Christen uses a T-shirt to promote his Web site (www.albin.ch).

Mike Quon's Marketing Tool Kit

- Online portfolios at Theispot-Showcase, WORKBOOK.COM and Portfolio Central
- Two Web sites: www.mikequondesign.com and www.designationinc.com
- Postcards (via snail mail and E-mail)
- Advertisements in The Workbook and other industry directories
- Personal notes: thanks-yous, birthday cards and vacation postcards
- E-mail marketing messages

Your Online Marketing "To Do" Lists

Now, you couldn't possibly use all the marketing tools discussed in this book, so you need to choose which ones are right for you, which ones fit into the marketing you're already doing. (You are already doing some marketing, right?) You need a plan, and not just a plan in your head, but a real plan, written down on paper (OK, maybe on computer). Unless you have a regular routine you can follow, your marketing efforts will yield inconsistent results at best. Your online marketing "to do" list, with activities to do daily, weekly, monthly and quarterly—needs to be integrated into your offline marketing plan that is already in progress.

The three sample plans that follow are the Web site-less plan, for those who want to start doing some online marketing while in the process of creating their Web site; a simple plan, for those who have a Web site, know that an online presence is necessary and don't want to spend too much time on it; and the ambitious plan, for those who are fascinated by the Web and want to make the most of this technology in their marketing. No matter which one you choose, all three plans will help you integrate your online marketing activities into the rest of your life. And if you diligently follow one of these plans, you'll create an online presence that makes you more visible month after month.

The Simple Five-Step Online Marketing Plan

1. Get listed in the major search engines.
2. Get registered in topic-specific industry directories.
3. Get linked to complementary and industry Web sites.
4. Mount an E-mail marketing campaign to those who know your work.
5. Use offline marketing tools (such as direct mail and networking) to drive traffic to your Web site.

Plan #1: The "To Do" List for the Web Site-Less

You do need an online presence, and just because you don't have a Web site yet doesn't mean you can't do any online marketing. Your online presence will consist of a digital portfolio posted on a portfolio site so you can send prospects to view it. The daily tasks for the Web site-less strategy requires more time proactively looking for prospects and projects—surfing job sites and auction sites to see what work is available. It's a good idea to make appointments with yourself (as you would with a client) to do this marketing work. Otherwise, it will be really easy to put off, and then, before you know it, the time is gone and you've done nothing. Here's what you need to start:

- An E-mail address with a signature file
- A portfolio posted online
- One-, two- and three-line blurbs about your services. (To be listed in online directories such as Yahoo! and other free sites, you must provide short blurbs as part of the submission process; it's helpful to have them ready and handy.)
- A package of samples to send at a moment's notice
- A registered domain name

Daily Tasks

First thing in the morning—thirty minutes
- Add new E-mail addresses to your E-mail list from messages you receive.
- Check job sites such as Monster.com and auction sites such as eLance.com for available projects.

End of day—thirty minutes
- Check in with your favorite discussion forum, and contribute three questions or answers.
- Skim a few of your favorite online newsletters for useful tips.

Weekly Tasks
- Surf for directory listing opportunities, and bookmark all possibilities.
- Get listed in one more online directory or free portfolio site.

Monthly Tasks: Your Web Site
- Continue surfing the Web to see the sites of others and evaluate how they work.
- Continue working on creating your Web site.

Plan #2: The Simple Online "To Do" List

Use this plan if you have a Web site but don't want to spend too much time promoting it. It will give you the basics and keep you involved in spreading the word. This is also good to start with if you're new to the Internet. You can work up to the ambitious tasks as you become more familiar with the technology and online marketing strategies. Here's what you need to start:

- An E-mail address with a signature file
- One-, two- and three-line blurbs about your services to list your site on directories
- A standard introductory E-mail message to request links to and from other Web sites
- Promotional postcards to announce your Web site

Daily Tasks

First thing in the morning—thirty minutes

- Add to your EZ-mail list new E-mail addresses from messages you receive.
- Check your Web site to make sure it's working properly.

End of day—thirty minutes

- Check in with your favorite discussion forum, and contribute one question or answer.
- Read or skim a couple of your favorite online newsletters.

Weekly Tasks

- Links: Surf for linking opportunities, and bookmark all possibilities.
- Registrations: Get listed in one search engine or online directory.
- Search Engines: Check your placement in one search engine.

Monthly Tasks: Your "Links" Page

- Send your introductory message to Webmasters about linking to or from their sites.
- Check to see if any of the links you've requested have been posted.
- Send out a batch of postcards promoting your site.

Quarterly Tasks

- Analyze your Web reports.
- Based on your analysis make changes such as additions, deletions and revisions to the navigation.
- Update your Web site: Add new work, remove old work and add links.

Plan #3: The Ambitious Online "To Do" List

Once you've been working the simple plan for a couple months, or if you've been online for a while and are familiar with the technology, try this ambitious plan. It will keep you involved in your online marketing on a very active level. Here's what you need to start:

- An E-mail address with a signature file
- One-, two- and three-line blurb about your services to list your site on directories
- A standard introductory E-mail message to request links to and from other Web sites
- Promotional postcards to announce your Web site

Daily Tasks

First thing in the morning—thirty minutes

- Add to your E-mail list new E-mail addresses from messages you receive.
- Check your Web site to make sure it's working properly.
- Check in with various (or "your favorite") discussion forums and contribute at least two messages.

During the day, fitting it into spare moments here and there

- Surf for linking opportunities, and bookmark all possibilities.

End of day—thirty minutes

- Check in with discussion forums, and contribute one question or answer.
- Read one or two online newsletters.
- Check to see if any of the links you've requested have been posted.

Weekly Tasks

- Links: Send your introductory message to five Webmasters about linking to or from their sites.
- Registration: Find one new online directory and portfolio site and sign up.
- Traffic: Review your weekly log files and compare to previous activity.

Monthly Tasks: E-mail Marketing Campaign and Continuous Update of Site

E-mail marketing will keep you in touch with prospects and keep them coming back to your Web site. Adding pages regularly will increase your exposure by giving your site more points of entry and show visitors that your site is not stagnant.

- Develop monthly E-mail marketing messages for your in-house list.
- Update your Web site: Add new work, remove old work and add links.
- Make changes based on your Web reports.

Quarterly Tasks:

- Check your placement in five search engines and resubmit if necessary.
- Improve your links page. Add a category or freshen up existing categories.
- Find E-mail newsletters in which your Web site can be featured.

So you've got your work cut out for you, but keep your expectations in check. Online marketing tools alone—especially your Web site—don't magically lead to new clients any more than direct mail or publicity do. Like offline marketing tools, they all work together. In fact, that's part of the beauty: using offline marketing tools to promote your online presence also promotes your work the old-fashioned way. For those clients who aren't yet online (and depending on the industry you're working in, that number could still be significant), a postcard announcing a Web site works just like any other direct marketing tool: it reminds them of your existence, jogs their memory a little, and if the time is right, could result in work, whether they view your digital portfolio or not.

Designer and illustrator Mike Quon says, "My intuition tells me to get people to see my work. The more places I'm linked and the more places I advertise, the better. And if I get one or two good jobs from the investment, it's well worth it because the alternative, not being online, gives the appearance of not embracing the new technology."

So find a way to fit it in and don't let it overwhelm you. You won't be sorry.

[*conclusion*]

```
- cd roms
- interface design
technology development

meetings/exhibits/environments
```

It's a fact that the reach of the Web and its ability to bring people together in their moments of need is unparalleled. You've read about designers and illustrators who, thanks to their electronic marketing tools, have made contacts they never would have made no matter how many trade groups they joined or cold calls they made. And it's true—there is tremendous opportunity here.

So the good news is that you now have at your disposal an arsenal of new marketing tools, each with a steep learning curve, that you'll have to decide when and how to integrate into your workday and your life.

If there's one point I've tried to make throughout this book, it's that although the Internet is a powerful marketing arena, the Web will not do your marketing for you. All the tools covered in this book require your participation, such as doing everything you can to drive traffic to your site rather than waiting for prospects to magically click through.

Online marketing is evolutionary, neverending and essential for everyone marketing creative services. It can open up opportunities galore. It can lead to your door prospects and clients about whom you could only dream, but not if you sit there dreaming.

This is a compilation of all the resources mentioned in this book, plus some additional online and offline resources. Be sure to visit the companion Web site for this book, www.selfpromotiononline.com, where this list will be posted and regularly updated.

General Online Marketing Resources
Web Marketing Portals
www.wilsonweb.com
www.efuse.com
www.virtualpromote.com
www.ceoexpress.com
www.emarketer.com/
www.clickz.com/

Professional Organizations
American Institute of Graphic Artists (AIGA; www.aiga.org)
Association of Professional Design Firms (www.apdf.org)
Association of Trial Lawyers of America (www.atlanet.org)
Corporate Design Foundation (www.cdf.org)
Design Management Institute (www.dmi.org)
Graphic Artists Guild (www.gag.org)
Internet Professional Publishers Association (www.ippa.org)
National Investor Relations Institute (www.niri.org)

Online Directories, Databases and Portfolio Sites
Fee-based
The Alternative Pick (www.altpick.com)
The Black Book (www.blackbook.com)
Designscout.com (www.designscout.com)
TheIspot-Showcase (www.theispot-showcase.com)
Planetpoint (www.planetpoint.com)
Serbin's Directory of Illustration (www.dirill.com)
The Workbook (www.workbook.com)

Free
About.com's Graphic Design Section (http://graphicdesign.about.com)
Portfolio Central (www.portfoliocentral.com)
Portfolios.com (www.portfolios.com)

More free database sites
www.adforum.com
www.artdirection.com
www.creativepro.com
www.designshops.com
www.dsphere.net/b2b/directory.html
www.findcreative.com
www.graphicdesigners.com
www.uscreative.com
www.aquent.com
www.netb2b.com
www.freeagent.com
www.guru.com
www.monster.com
www.ework.com
www.icplanet.com
www.soloskills.com
www.ants.com

Online Auction Sites
www.elance.com
www.guru.com
www.freeagent.com
www.iniku.com
www.monster.com
www.uscreative.workexchange.com

Online Marketing Resources
Domain name registration
www.register.com
www.networksolutions.com

Search engine submission services
www.submitit.com
www.123add-it.com
www.selfpromotion.com
www.websitegarage.com

Info about search engines
Search Engine Watch (www.searchenginewatch.com)

Free online mailing list services
www.egroups.com
http://topica.com
http://listbot.com

Online press release distribution
www.businesswire.com
www.mediamap.com
www.newsbureau.com
www.prnewswire.com
www.urlwire.com

Online portfolio galleries
www.adobe.com
www.corel.com
www.eyewire.com
www.electronic-publishing.com
www.macromedia.com/gallery

Market research
Dun & Bradstreet (www.dnb.com)
Hoovers Online (www.hooversonline.com/)
Web Marketing Research (www.webcmo.com)
Thomas Register of American Manufacturers (www.thomasregister.com)
The Worldwide Directory of Chambers of Commerce (www.chamber-of-commerce.com)

Offline mailing lists
Ad Base Creatives (www.adbasecreatives.com)
American Business Information (www.salesleadsusa.com)
American List Counsel (www.amlist.com)
Creative Access (www.creativeaccess.com)
Edith Roman (www.edithroman.com)
The Workbook (www.workbook.com)
The List (www.thelistinc.com)

Design-Oriented Online Forums and Discussions

About.com Graphic Design Discussion (http://graphicdesign.about.com/)

Art Talk (www.Theispot-Showcase.com)

Creative Pro (www.creativepro.com)

The Design Forum (www.mediadrone.com/forum)

The Designers Network (www.designers-network.com)

HOW Magazine Forum (www.howdesign.com)

Business-Oriented Online Forums and Discussions

Delphi Forums (http://forums.delphi.com/)

Fast Company (www.fastcompany.com)

Onvia (www.onvia.com)

Red Herring (www.redherring.com)

Verticalnet (www.VerticalNet.com)

Web Site Tracking Software and Log Reports

www.bravenet.com

www.extreme-tracing.com

www.webtrends.com

Offline Postcards for Promoting a Web Site

Web Cards (www.wbcards.com) (800) 352–2333

Miscellaneous Online Marketing Tools

Free scripts and forms (http://www.response-o-matic.com)

Shareware Web site (www.tucows.com)

Online Collaboration: Marketing Central (www.marketingcentral.com)

Web rings (www.webring.org)

Online Publications

Visual Arts Trends (www.VisualArtsTrends.com)

Dan Janal's online marketing magazine (http://www.janal.com)

Journal of the Hyperlinked Organization (*JOHO*, http://www.hyperorg.com/forms/form.html)

SalesDoctors Magazine (http://salesdoctors.com)

Larry Chase's Web Digest for Marketers (http://wdfm.com/)

Books About Online Marketing

Essential Business Tactics for the Net, by Larry Chase

Online Marketing Handbook, by Dan Janal

Getting Hits: Promoting Your Web Site, by Don Sellers

101 Ways to Promote Your Web Site, by Susan Sweeney

Poor Richard's Internet Marketing & Promotions, by Peter Kent and Tara Calishain

Poor Richard's Email Publishing, by Chris Pirillo

Marketing Online, by Marcia Yudkin

The Cluetrain Manifesto, by Rick Levine, Christopher Locke, Doc Searls and David Weinberger

The Web Design WOW! Book, by Jack Davis and Susan Merritt

Contact Info for Designers, Illustrators and Writers Featured in This Book

Jed Block (Appleton, WI; www.jedblock.com)

Harry Campbell (Baltimore, MD; www.hspot.com)

Albin Christen (Lausanne, Switzerland; www.albin.ch)

David Curry, David Curry Design (New York, NY; www.davidcurrydesign.com)

Ilena Finocchi Illustration and Design (North Lima, OH; www.ifid.com)

Frankfurt Balkind (New York, NY; www.frankfurtbalkind.com)

Grapefruit Design (Bulgaria; www.grapefruitdesign.com)

Guarino Woodman (New York, NY; www.guarinowoodman.com)

Lecours Design (Manhattan Beach, CA; www.lecoursdesign.com)

Ivan Levison (Greenbrae, CA; www.levison.com)

Jeff Fisher LogoMotives (Portland, OR; www.jfisherlogomotives.com)

McElligott Graphics (Albany, NY; www.mcegraphics.com)

Monster (Northern CA-based collective of illustrators; www.monsterillo.com)

Bud Peen (Oakland, CA; www.budpeen.com)

Pentagram (New York, NY; www.pentagram.com)

Mike Quon Design, Designation (New York, NY; www.mikequondesign.com)

Sibley Peteet Design (Dallas, TX; www.spddallas.com)

Thoden Design (VA; www.thodendesign.com)

Top Design (Los Angeles, CA; www.topdesign.com)

Roxana Villa (Los Angeles, CA; www.roxanavilla.com)

watersdesign.com (New York, NY; www.watersdesign.com)

Wee Small Hours Design (New York, NY; www.weesmallhoursdesign.com)

Michael Wertz (San Francisco, CA; www.wertzateria.com)

XPLANE (St. Louis, MO; www.xplane.com)